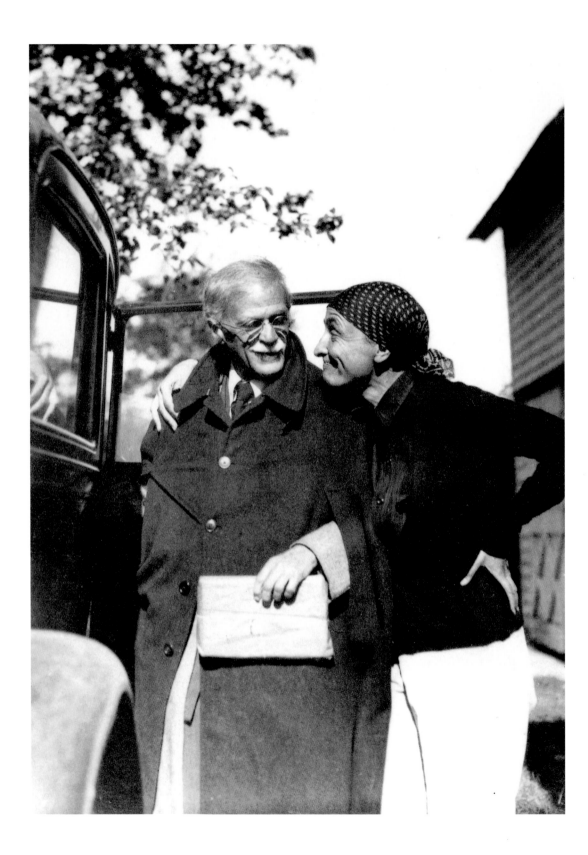

Peter-Cornell Richter

Georgia O'Keeffe
and Alfred Stieglitz

Prestel

Munich · London · New York

Front cover: Georgia O'Keeffe, *Dark
Iris*, 1927, Fine Arts Center, Colorado
Springs, CO (see page 84)

Frontispiece: Georgia O'Keeffe and
Alfred Stieglitz framed by the door
of Georgia's beloved Model-A Ford,
photograph, now in the Collection
of American Literature, The Beinecke
Rare Book and Manuscript Library,
Yale University, New Haven, CT
Spine: *Spring Showers (The Sweeper)*,
1902, The Minneapolis Insitute of Arts,
Minneapolis, MN, detail (see page 103)
Page 5: *Winter, Fifth Avenue*, New
York, 1893, Museum of Fine Arts,
Boston, MA (see also page 28)

Translated from the German by
Ishbel Flett, Frankfurt/Main
Copyedited by
Courtenay Smith, Munich
Editorial direction by
Christopher Wynne

Library of Congress Card Number:
99–069113

© Prestel Verlag
Munich · London · New York, 2001
© of works illustrated
by Georgia O'Keeffe,
by VG Bild-Kunst, Bonn, 2001

Prestel books are available worldwide.
Please contact your nearest bookseller
or one of the following Prestel offices
for details concerning your local
distributor:

Mandlstrasse 26
80802 Munich
Tel. (089) 38 17 09-0
Fax (089) 38 17 09-35;

4 Bloomsbury Place
London WC1A 2QA
Tel. (020) 7323 5004
Fax (020) 7636 8004;

175 Fifth Avenue
New York, NY 10010
Tel. (212) 995-2720
Fax (212) 995-2733

Designed by Matthias Hauer
Cover Design: F. Lüdtke,
A. Graschberger, A. Ehmke, Munich
Typeface: ITC Clearface
Lithography by ReproLine, Munich
Printed by Passavia Druckservice,
Passau
Bound by Conzella, Pfarrkirchen

Printed in Germany on acid-free paper

ISBN 3-7913-2312-1

Contents

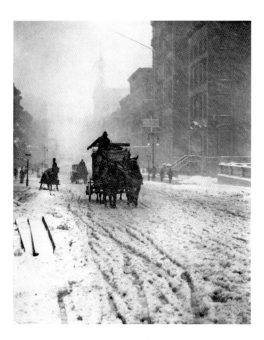

When Georgia O'Keeffe painted *Sky above Clouds* in 1965 — nineteen years after Alfred Stieglitz's death — she entered the enigmatic realm of Stieglitz's *Equivalents*, gazing down upon a world that, to him, had been the plane onto which he projected his innermost feelings. In *Sky above Clouds,* O'Keeffe created a painting in which, for perhaps the last time, her life and work seemed to merge with the life and work of her lover Alfred Stieglitz.

Georgia O'Keeffe, *Sky above Clouds IV*, 1965, oil on canvas, 243.8 x 731.5 cm, The Art Institute of Chicago, Chicago, IL, Restricted gift of the Paul and Gabriella Rosenbaum Foundation, Gift of Georgia O'Keeffe

The painting is more than twenty feet wide and depicts clouds which, like celestial paving, invite the spectator to walk into the horizon. Far below the clouds is the sea and high above them an infinitely blue sky. In between is a broad band above the horizon that shimmers in a pale pink light. It is an image brimming with hope, joy, breadth of vision, and wisdom.

When Georgia O'Keeffe was born, Alfred Stieglitz was already twenty-three years old and acheiving acclaim as an extraordinarily innovative photographer. Thus, to draw together these two lives is like combining two melodies within a single score in which neither is dominant. The young woman and the older man inspired each other with impassioned enthusiasm. They drew one another into a creative euphoria that has given us paintings and photographs whose contemporary relevance and captivating power have not faded, even decades after they were produced. Georgia O'Keeffe and Alfred Stieglitz created works of art that pandered neither to public taste nor to passing fads. Their pictures illustrate only their profoundly personal dialogues with the world.

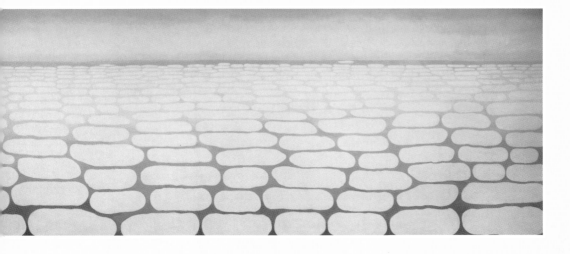

*Art is an imitation of the nature of things,
not of their appearances.*

Ananda K. Coomaraswamy, 1941

Biographies

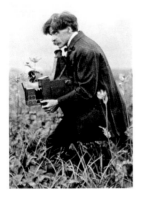

Heinrich Kühn, *A. Stieglitz with his Graflex*, 1904

1864	Alfred Stieglitz is born in Hoboken, New Jersey, on January 1, as the eldest of six children.
1871	The family moves to Manhattan, 14 East Sixtieth Street.
1871–79	Stieglitz attends a private school in New York.
1879–81	City College, New York
1881–82	High school in Karlsruhe, Germany. High school diploma (*Abitur*).
1882–90	Studies at the technical college and later at the university in Berlin.
1883	Stieglitz buys his first camera. Starts studying photochemistry under Professor Hermann Wilhelm Vogel.
1880s	Travels throughout Germany, Italy, Switzerland, and Austria.
1885	First contributions published in German and English language magazines.
1887	Georgia O'Keeffe is born on November 15 near Sun Prairie, Wisconsin, as the second of seven children. Stieglitz is awarded 1st prize in the international competition 'The American Photographer' in London, by Peter Henry Emerson.
1888	The Stieglitz family purchases the property Oaklawn on Lake George.
1890	Stieglitz returns to New York on the death of his sister Flora in California.
1891	Joins the Society of Amateur Photographers.
1893	Stieglitz marries Emmeline Obermeyer, the sister of a friend. He becomes the editor of 'American Amateur Photographer.'
1894	Spends the summer in Europe. He joins the

Linked Ring, an avant-garde association of British photographers.

1896	Ends his editorship of 'American Amateur Photographer.' The Society disbands and merges with the New York Camera Club.
1897–1902	Publishes 'Camera Notes.'
1898	His daughter Katherine is born.
1902	Stieglitz founds the 'Photo Secession.'
1903–17	Founds the magazine 'Camera Work' and works as its editor.
1904	Stieglitz spends the summer in Europe.
1905	O'Keeffe enrolls at art school in Chicago.
1907	She continues her studies at the Art Students League in New York. Stieglitz travels to Europe with his wife. *The Steerage* is taken.
1908	O'Keeffe and Stieglitz meet for the first time, shortly after Stieglitz had founded the Photo Secession gallery in New York, soon to be known simply as 291.
1908–10	O'Keeffe earns her living as a commercial artist in Chicago.
1909	Stieglitz's father dies. Modern American art is presented at the 291 gallery for the first time (Marsden Hartley). Stieglitz spends the summer in Europe where he meets up with Heinrich Kühn

Alfred Stieglitz, *Georgia in Lake George*, 1918, George Eastman House, Rochester, NY

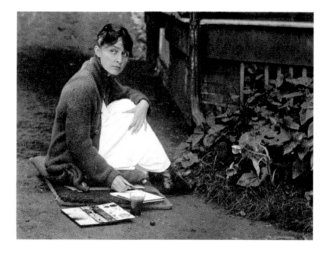

and Edward Steichen. First joint efforts with autochrome negatives.

1910 International exhibition of Photo Secession artists at the Albright Art Gallery in Buffalo.

1911 Stieglitz's last journey to Europe.

1912 The O'Keeffe family moves to Charlottesville, Virginia. Georgia O'Keeffe works as an art teacher for two years in Amarillo, Texas.

1913–16 O'Keeffe becomes assistant to Alon Bement during the University of Virginia's summer school.

1915–16 Stieglitz publishes the art magazine '291.'

1916 O'Keeffe and Stieglitz meet consciously for the first time. O'Keeffe's first exhibition at 291 is held.

1917 O'Keeffe's first solo exhibition at 291. Stieglitz then closes down his gallery. Last issue of 'Camera Work' is published. The first photographs for Stieglitz's comprehensive 'Portrait' of Georgia O'Keeffe are taken.

1918–20 Both artists work together in the studio on East Fifty-Ninth Street. O'Keeffe and Stieglitz begin their relationship.

1922 Stieglitz's mother dies. Part of Oaklawn is sold.

1924 O'Keeffe and Stieglitz marry after his divorce has been finalized. Ananda Coomaraswamy purchases twenty-seven photographs by Stieglitz for the Museum of Fine Arts in Boston.

1925 Stieglitz opens the Intimate Gallery. Group exhibition of the 'Seven Americans': Georgia O'Keeffe, Charles Demuth, Arthur Dove, John Marin, Marsden Hartley, Paul Strand, and Alfred Stieglitz.

1927 O'Keeffe undergoes two breast operations.

1928 The Metropolitan Museum, New York, purchases photographs by Stieglitz.

1929 O'Keeffe travels to Taos, New Mexico, with Rebecca (Becky) Strand, Paul Strand's wife. O'Keeffe begins her correspondence with D.H. Lawrence. Her work is included in a group exhibition at the Museum of

Modern Art, New York. Having closed the Intimate Gallery, Stieglitz opens the gallery An American Place.

1933 Stieglitz publishes *Dualities*, a volume of poetry by Dorothy Norman, who will later write his biography, *Alfred Stieglitz: An American Seer.*

1934 The Metropolitan Museum in New York purchases its first painting by Georgia O'Keeffe. She spends her first summer on Ghost Ranch.

1939 Nancy Newhall begins work on a biography of Alfred Stieglitz. She dies in 1979 and the texts are published posthumously by her husband, Beaumont Newhall in 1989 under the title *From Adams to Stieglitz.*

1940 O'Keeffe purchases a small holding on Ghost Ranch (Rancho de los Burros) near Abiquiu, New Mexico.

1945 Buys a house in Abiquiu.

1946 Alfred Stieglitz dies on July 13.

1949 O'Keeffe moves to New Mexico for good.

1953 She make her first trip to Europe.

1956–60 Travels to South America (1956), India (1959), Japan, and some Pacific islands (1960).

1961 Goes rafting on the Colorado River (repeated in 1969 and 1970).

1963 Travels to Greece and Egypt.

1971 O'Keeffe's eyesight begins to fail.

1973 Juan Hamilton becomes her assistant.

1976 Her autobiographical text 'Georgia' is published in *Georgia O'Keeffe: A Study Book* (Viking Press, New York).

1983 O'Keeffe's last meeting with Ansel Adams, who dies the following year. Travels to Costa Rica with Juan Hamilton.

1984 Produces her last drawings.

1986 Georgia O'Keeffe dies on March 6.

1989 The Georgia O'Keeffe Foundation is established in Abiquiu.

Prelude

Liberal and tolerant, rebellious and intellectual—such were the characteristics of the families into which Georgia O'Keeffe and Alfred Stieglitz were born. O'Keeffe's father was a young Irish farmer by the name of Francis, and her maternal grandfather, Victor Totto, was a Hungarian count who had emigrated to the United States in 1849, following an attempted Hungarian revolt against Austrian hegemony.

That same year, Stieglitz's father, Edward, arrived in the New World as a young man, inspired by the liberal ideals of the similarly unsuccessful German revolution of 1848. Both families not only cherished ideals of freedom but also a deep love of literature and music.

Widespread Puritanism in the United States did not affect the O'Keeffe or the Stieglitz families, as religious affiliations played no role in their lives. Nor did their Hungarian-Irish Catholic or German-Jewish ancestries, respectively, succeed in making any mark on the families beyond factual entries in their family documents.

The immigrants to this relatively new confederation of states were driven by an almost overwhelming faith in their own capabilities. A sense of boundless new opportunities prevailed, as did a pioneering spirit bent on subjugating the land with single-mindedness and aggressiveness that brooked no resistance, sweeping men and women along in its tide. It was a merciless and unyielding determination, fueled by an alarming faith in success and the right of the strongest. This phenomenon con-

tinues to survive to this day in the form of an optimism and unflinching conviction that is hard for Europeans to understand.

This optimism, supported by an awareness of the country's expanse, its rapidly sprawling cities, and the concomitantly fascinating and oppressively soaring industrial architecture of the metropoli, became an integral part of the dynamic self-assurance of the immigrants. Perhaps we can find in this an explanation for the extraordinary vitality of modern American art that is as evident in the bold, monotone canvases of Ellsworth Kelly as it is in Keith Haring's comical figures. Its dark side can be found in the loneliness of Edward Hopper's visual world, its rigor in the calligraphy of Franz Kline and Mark Tobey. It is an art that almost always possesses a certain magnificence—a magnificence that is never grandiose but almost invariably generous. At times it is even modest, as in the work of John Marin or Morris Graves. Perhaps modesty is a common quality of American artists who harbor a little of the Old World in them, no matter which continent their forebears hailed from.

When Georgia O'Keeffe was born, there was no approach to art that could be described as essentially American. Artists tended to look towards Europe, creating portraits, genre scenes, and still lifes. European taste had come to America with the emigrants' ships and had permeated artistic training. Unlike the rest of the social fabric, the art world had yet to acquire a truly American consciousness, although there were a few exceptions. From the outset, the work of Mary Cassatt and Frederic Remington was refreshingly different from the European art of the nineteenth century.[1]

Mary Cassatt's (1845–1926) upbringing had a distinctly French flavor, yet she became a thoroughly American painter. At the

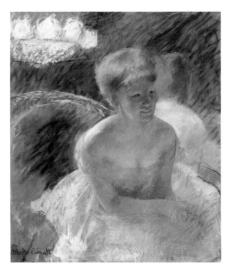

advice of her mentor Edgar Degas, she joined the circle of the
French Impressionists. Her atmospherically dense paintings
were not the result of an enthusiasm for the magic of light and
its fragmentation in color; her work was determined entirely
by her love of the everyday. She liberated hackneyed motifs,
such as her favorite subject of mother and child, from their
conventional and artificial modes of representation, jettison-
ing all literary ballast and rendering them realistically. Her
impressionistic touch had more to do with the tenderness with
which she expressed her affection for the subject matter in the
course of the creative process than with an analytical fragmen-
tation of light.

Frederic Remington (1861–1909) also springs to mind as a very
American artist. In his youth, he had worked as a cattle drover
in the West, and this experience had a profound and lasting
impact on his work as a painter and sculptor. For him, only the
real and tangible environment was his subject matter, and he
approached it with enormous respect.

Even in the work of these two very dissimilar painters, we see something that is evident in the work of almost all of the fine artists of North America: they feel a far closer affinity to reality than their European counterparts. And they retain that affinity even when their work is abstract. Consider for a moment Robert Rauschenberg, who actually included real objects such as chairs or stuffed birds in his works, or Jackson Pollock, who used the energy-laden choreography of his own body to express himself in paint. These artists do not plumb psychological depths. They work with what they can relate to directly and sensually.

What about photography? Apart from a few mavericks, American photography in the nineteenth century was mostly documentary, although notable exceptions are still key figures in the history of photography: Jacob Riis (1849–1914) and Lewis Hine[2] (1874–1940) in New York and William Henry Jackson (1843–1942) and Eadweard Muybridge (1830–1904) in the far west. Jacob Rijs and Lewis Hine may be described justifiably as the first pioneers of committed photojournalism. They insti-

Lewis Hine, *Newspaper boy*, 1916, Courtesy of the Freddy Langer Collection, Frankfurt a.M.

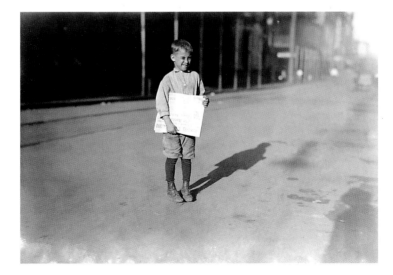

gated that admirable group that soon came to be known as "concerned photographers," among them Robert Capa, Eugene Smith, Werner Bischof, and Dorothea Lange, to name but a few.

William Henry Jackson and Eadweard Muybridge founded the unique tradition of American landscape photography that was later to reach its culmination in the work of Edward Weston, Ansel Adams, Wynn Bullock, and Minor White.

The many professional and amateur photographers of the late nineteenth century, mainly organized in clubs, were far from grasping the possibilities that photography offered them. It was Alfred Stieglitz who was to open their eyes and those of their American audience.

Alfred Stieglitz I

Alfred Stieglitz was born in Hoboken, New Jersey on January 1, 1864. His mother, Hedwig Werner, was a German who had emigrated to the States as a child with her parents from the small town of Offenbach am Main, near Frankfurt. His father, Edward Stieglitz, was also German, from Hannoversch Münden. Following a period of voluntary military service in the New York State Militia during the Civil War, Edward Stieglitz settled in Washington, D.C., where he worked as a cotton merchant. He later moved to Hoboken, New Jersey, and, in 1871, the family moved to Manhattan in New York City. Together with his three sisters and two brothers, Alfred enjoyed a comfortable and sheltered childhood in a home where tolerance for, and a love of, music, literature, and the arts held sway.

Alfred Stieglitz, *Self-Portrait*, Berlin 1886, Yale University Art Gallery, New Haven, CT

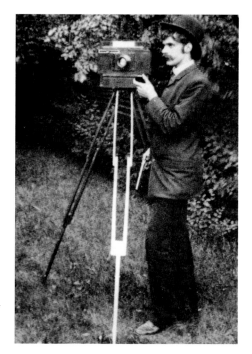

In 1881 Edward Stieglitz retired and traveled to Germany in order to educate his children at a German school. The family chose the Realgymnasium in Karlsruhe, and, one year later, in 1882, Alfred Steiglitz passed his Abitur examination, thereby qualifying for university entrance.

His father decided that his son should study in Berlin, so Alfred enrolled at the Technische Hochschule there to study mechanical engineering. The following year, a minor incident triggered an important chain of events. Passing by a shop, Alfred Stieglitz saw a camera displayed in the window and bought it on impulse. The camera was a simple wooden device for 5 x 8 inch glass plates, with a fixed lense that had no shutter. Stieglitz also purchased some developing trays, a ruby lamp, and an instruction manual explaining how to use a camera and darkroom. In total, he spent the equivalent of seven-and-a-half US dollars.

As he familiarized himself with his camera, his enthusiasm grew. It was this enthusiasm that persuaded him to change his university training to photochemistry. By a stroke of good luck, he studied with Professor Hermann Wilhelm Vogel, who, even today, is regarded as one of the most important figures in early photographic history. In 1873 he developed the orthochromatic emulsion that made it possible to sensitize negatives — previously receptive only to blue — for all colors except red. Vogel is also regarded as the father of the panchromatic film that we still use today — an invention he foresaw but was unable to produce himself. Unfortunately, it is all too often forgotten that Vogel was also the first serious theoretician of photographic aesthetics.[3]

Vogel was quick to recognize the great talent of his new student and also noted Stieglitz's tendency to call into question seemingly unassailable tenets of photographic technique. Vogel was all too happy to encourage this aspect of his stu-

dent's interest. For example, it was regarded as impossible to produce a finely drawn rendering of the contrast between, say, white marble and black velvet, on a photographic negative. Yet, after weeks of experimentation, the young Stieglitz proved it could be done. Likewise, the idea of taking a photograph in any condition other than daylight was considered utterly absurd. However, as a student, Stieglitz produced a perfect negative that he had exposed for twenty-four hours by the dim light of an electric bulb in the basement of the Polytechnic.

Unlike his fellow students, Stieglitz was never satisfied with the first attempt at solving a problem. He was always the student who worked longest on a problem. As a result, his solution was usually the best and, as often as not, the only satisfactory one. The other students soon came to regard him as the "crazy American," an epithet of which he was proud. His teacher, in turn, was proud of him.

Stieglitz was always fascinated by what the modulation of light could reveal about the outward appearance of an object. This fascination brought him to the insight that photography was capable of far more than merely reproducing outward appearances, which after all, were the results of inner occurrences and developments. This is particularly true of the portrait, which, even today, poses a great photographic challenge. Though the camera is a technical apparatus with optical and mechanical devices, it is invariably guided by the subjective view of the person operating it. It is this human quality, rather than any technical properties, that informs the picture and guards against its subordination to the electronic brain of the appliance.

The personality of each individual is a unique mosaic that develops constantly. Education and experience are as much a part of this mosaic as are music, literature, art, and religion.

When artistic activity occurs on the basis of this mosaic, in harmony with subject matter and the prevailing era, then it can be described as artistic responsibility. Only in this way can a work of art gain its inimitable signature or be touched by what Stieglitz later to described as "truth."

Thanks to the careful guidance of Vogel, who was keenly aware of the special talent of his student, and due to his own alertness, Alfred Stieglitz soon developed an artistic sense of responsibility that was mature for someone of his age and not necessarily a product of his photographic or artistic education.

Georgia O'Keeffe I

Georgia O'Keeffe, too, was fortunate to have a teacher who recognized and nurtured her talent. Yet before teacher and pupil met, O'Keeffe had already gained an important formative experience through the intensity of her encounter with nature and landscape in a rural environment. It was her early familiarity with this subject matter that would one day make her famous.

Georgia O'Keeffe was born on November 15, 1887 — the second of seven children of Ida Totto O'Keeffe and Francis Calyxtus

Alfred Stieglitz, *Georgia O'Keeffe, Hands in front of the bark of a tree*, 1918, Private Collection

O'Keeffe—on a farm near Sun Prairie, Wisconsin, a few miles northeast of Madison. The rolling prairie with its elm trees, sunflowers, and cornfields was the paradise in which she spent the first twelve years of her life. It was a paradise transformed in winter by heavy snowfalls and the chilling winds that blew across the Canadian border. For O'Keeffe and her siblings, winter meant many months of painting, music making, and reading. Their stern mother and jovial father placed great importance on the children's creativity. With their father, they sang Irish songs, and with their mother, they painted. When it became clear that Georgia possessed particular artistic talent, she was allowed to attend private lessons given by Mrs. Sarah Mann at Sun Prairie, some six miles away. The painting and drawing she enjoyed so much then took on enormous significance for her, and it is said that she expressed her intention of becoming an artist when she was twelve years old.

During the harsh winter of 1901–02, her parents decided to sell their farm. One year later, they moved to Williamsburg, near the Atlantic coast of Virginia, with their three youngest children. Georgia and the other three children went to live with relatives in Madison, where they attended school, until 1903. They then rejoined their parents in Virginia where they brought a breath of fresh air to the strict southern Protestant town of Williamsburg. There, Georgia attended a reputable girls' boarding school at Chatham—some 120 miles away—a community between the small town of Roanoke to the north and the border of North Carolina to the south.

The head of the boarding school, Mrs. Elizabeth May Willis, was also the art teacher. Soon realizing that her new pupil was extremely gifted, she made every effort to nurture her promising talent. When O'Keeffe graduated from high school two years later, Mrs. Willis encouraged her to enroll at the Art Institute of Chicago under the tutelage of John Vanderpoel.

Vanderpoel was a fine draftsman and a keen admirer of female beauty whose portraits of women still exude a remarkable vitality. He taught O'Keeffe that the outer form of the body invariably and necessarily takes shape from within and that line and shading should be applied with the awareness that they represent the external appearance of a complete living entity. Vanderpoel also taught her about composition based on anatomy and spoke of the sensual perception of the motif and of analogies between the forms of nature, the human body, and sexuality.[4] To Vanderpoel, all of creation was a single organism whose myriad facets were interrelated. In this respect, he was far ahead of the art educational practice of his day, even though, on the whole, his methods remained indebted to the traditional painting of the European schools. O'Keeffe followed his lectures and exercises with great enthusiasm, and though she stayed in Chicago for little more than a year, Vanderpoel's influence remained the most evident and enduring in her later oeuvre.

In 1906 O'Keeffe contracted typhus. After months of illness and recuperation, she resumed her studies in New York the following year at the Art Students League—the most renowned art school in the United States at the time, with a reputation for being run along conservative lines. There she studied with William Merrit Chase, a painter held in the highest esteem by New York society since he was highly skilled, technically. Though extraordinarily capable of realistically rendering the texture of any material—be it the bark of a tree, locks of hair, skin, or fabric—Chase's works were highly decorative, a quality that counted in New York society but which was not particularly advanced. During this period, O'Keeffe sought to perfect her technical skills as a painter and did so to the great satisfaction of her teacher. What she missed in creative adventure at the Art Students League, she made up for by visiting a small New York gallery on Fifth Avenue. It was named after its house number, 291. The gallerist was Alfred Stieglitz.

Alfred Stieglitz II

By this time, Alfred Stieglitz was already a photographer of international rank who had enjoyed the privilege of a predominantly European education. Ever hungry for knowledge, he had quickly familiarized himself with European traditions and the cultures in which they were rooted. At the same time, he was keenly aware of the turn-of-the-century shift toward new theories and new forms of expression in art as in music. Thus, in the vast metropolis of New York, on the fourth floor of an old brownstone, he began setting up something akin to an experimental laboratory dedicated to a new generation of artistic ideas. For a photographer in those days, 291 was nothing short of remarkable.

As a student, Alfred Stieglitz had eagerly devoured subjects of interest to him at Berlin's places of higher education, where he attended lectures on literature, art history, and philosophy. He also tried to see as much of Europe as he could on his annual budget of 1,300 dollars. In so doing, he acquired a well-founded knowledge of art and photography.

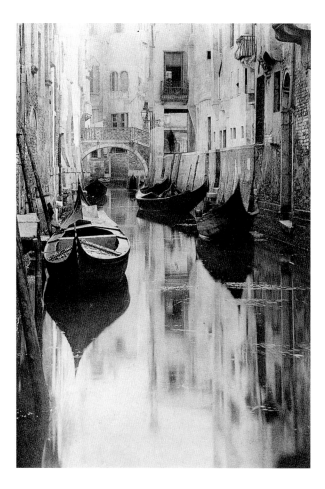

Alfred Stieglitz, *A Venetian Canal*, 1897, University of New Mexico, Albuquerque, NM

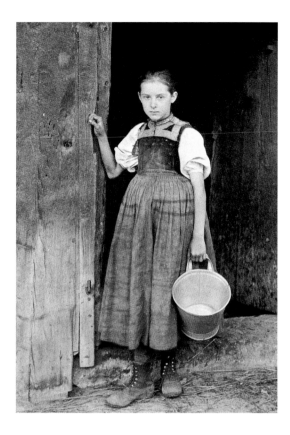

Furthermore, his photographs of the streets and alleyways of Venice brought him his first taste of international recognition when, in 1887, The Royal Photographic Society of Great Britain and critic Peter Henry Emerson lauded his work as immediate, spontaneous, and honest photography. The photographs still strike viewers in this way, reflecting, as they do, Stieglitz's profoundly personal and intense experiences on his way through the Old World—a world that would soon seem more familiar to him than his own homeland on the East Coast of the United States. While he was in Europe—no less than nine years in all—the distant America of his childhood appeared to him through the eyes of the many Europeans who had never been there. This gave him the opportunity to see it as they did, as a land of social justice and art appreciation.

America

When Alfred Stieglitz was called back to New York by his family in 1890, following the death of his eldest sister, he found an America far removed from the land of his dreams — in spite of its undeniable technical acheivements. Business alone appeared to be the driving force behind the culture, and it shaped daily life in the metropolis. A high and steadily increasing rate of unemployment was exacerbated by the flood of immigrants from Europe and the Mediterranean whose hopes and dreams, like his own, had been abandoned in the dockyards but not forgotten. "It was strange," he remarked some time later, "to experience such unhappiness in my homeland among my own people." The social unrest affected his personal situation as well, when he discovered how little other people were interested in the subject that was so close to his heart. "I soon realized that 'photography,' as I understood the concept, hardly existed in the USA. The photographic scene, like much else, was disconcerting."[5]

Stieglitz was horrified also to find American photography lagging so far behind that of Europe. No one seemed to consider the camera as an artistic medium. On the contrary, it had been degraded to a mere plaything: the slogan introduced by George Eastman[6] — "You press the button, and we do the rest" — had made every American a photographer. According to Stieglitz, "Every Tom, Dick, and Harry could, without trouble, learn how to get something or other on a sensitive plate, and this was what the public wanted — no work and lots of fun."[7]

Stieglitz felt himself a stranger in this New York atmosphere. He moved with his camera in the midst of incredible masses of

people, and yet he felt alone. After his productive student years and close friendships in Berlin, the apparent intellectual indifference of New York was a bitter disappointment.

Earning his living by photography without pandering to public taste seemed to be an impossible task. Since he was not prepared to compromise, he let himself be persuaded by his father to invest his photochemical training in a company that printed high-quality photoengravings: "Our firm, first called the Heliochrome, then the Photochrome Engraving Company, gained respect for doing work of fine quality including color reproductions. Speed, however, and quantity were demanded rather than careful craftsmanship."[8] Yet, the proprietors of this ambitious company had little for Stieglitz to do, so he made a virtue of necessity and spent much of his time wandering around town with his camera, hoping that, in this way, he might make New York his home. Since he had no studio of his own, he joined the New York Society of Amateur Photographers and used their darkrooms to process his negatives and make contact prints.

Photographs

One winter day in 1893, the city of New York was hit by a blizzard. Alfred Stieglitz was standing at the corner of Thirty-Fifth Street and Fifth Avenue watching the horse-drawn carriages and stagecoaches lumbering through the snowstorm. He wondered whether he could capture the atmosphere of this scene in a single image with a hand-held camera, so he tried. In so doing, he considered carefully each step that might help him to achieve his aim.

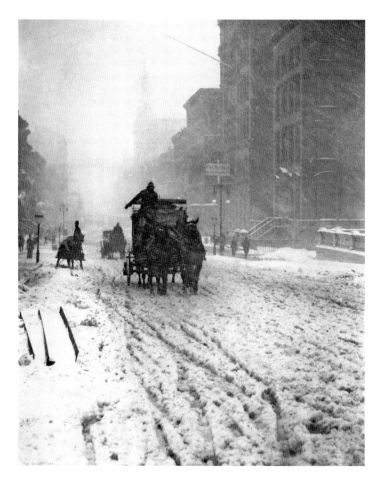

Even before the negative had dried, he showed it to the other club members. They all laughed. One even said, "For God's sake, Stieglitz, throw that damned thing away. It is all blurred and not sharp."[9] Yet when he showed them the finished picture the next day, they could not believe that it had come from the same negative they had seen the previous day. When they found it was true, they applauded him.

At that time, each photographic exposure was regarded as an enterprise with an uncertain outcome. No amateur dared to say in advance whether a photograph would develop or not. Professional photographers could draw on their own experiences, but much depended on the weather, the lighting conditions, and the season.

Then along came Stieglitz, claiming not only that he had chosen the right exposure, but that he had expressed the atmosphere of a particular situation within a consciously planned image. With this direct and successful example, his notion that photography might be more than just a sporting pleasure caught on and was adopted with enthusiasm. Once Stieglitz convinced his fellow members that his photograph was not a novelty, the club turned into a meeting place of people with serious photographic ambitions and exacting standards. Only a few years later, some of its members, together with other amateurs inspired by Stieglitz, founded the Photo-Secession, based on the European model. It brought American photography to the forefront to gain the respect and recognition it still enjoys. The names Anne Brigman, Alvin Langdon Coburn, Frank Eugene, Gertrude Käsebier, Joseph A. Keiley, Eva Watson-Schütze, Edward Steichen, and Clarence H. White have lost nothing of their resonance.

Alfred Stieglitz gave his pivotal photograph the title *Winter, Fifth Avenue*. Not only was it his first photograph taken with a hand camera, it also became his most highly accoladed and frequently purchased image. The American photographic essayist Sadakichi Hartmann commented: "I, as a literary man, would feel proud if I could express a 'Winter Day' in words with the same vigor, correctness, and individual note as Mr. Stieglitz in his photographic plate."[10]

Later that same winter, Stieglitz succeeded in producing the photograph that would reconcile him with his city. It was an

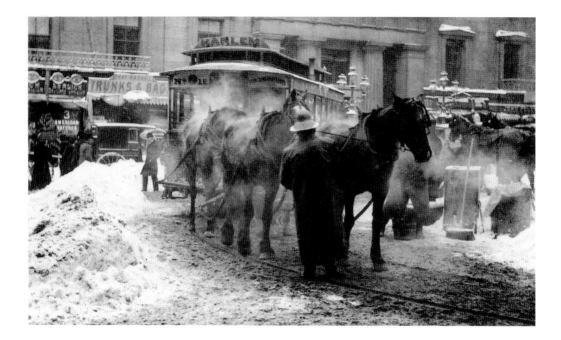

unusually cold day, and Stieglitz was standing at the terminal of the horse-drawn tramway, opposite the old Astor House, watching a driver tending his two horses. Stieglitz's sense of loneliness in his own city disappeared when he saw how lovingly the man tended the animals in his care. Here, he encountered affection and care. Such moments gave him hope and, in time, a sense of belonging. These feelings are suggested in his photograph, which he titled *The Terminal.*

Stieglitz evaluated photography, like any other art form, strictly according to its "truth" content. Truth, to him, did not mean simply the detailed reiteration of the subject matter. Above all, it involved capturing the atmosphere or spirit of a visual situation through purely photographic means. This was an uncommon concept in his time, but there were photographers who fulfilled these criteria. Artists such as Julia Margaret Cameron, Gaspar Félix Tournachon, who called himself Nadar, and a number of others already worked in this way. Yet few people

gave their work serious thought or considered it the subject of theoretical discourse or analysis. Photography was still untouched by the possibility of an artistic identity. Thus, Stieglitz became the first theoretician of modern photography, setting a standard that remains a benchmark.

Supreme craftsmanship alone was not enough. Artistic inspiration had to come from within, as in the photographs Stieglitz took in the winter of 1893. His collaboration with Hermann Wilhelm Vogel had proved fertile indeed, for it enabled Stieglitz to demonstrate that the camera need not be regarded as a barrier between sensibility and subject matter. Once he had disproved the arguments of those who refused to place photography on a par with the other fine arts, Stieglitz regarded his life and work as a struggle for the general recognition of photography as a visual process that could be used, in capable hands, to creative and artistic ends. For Stieglitz this struggle meant promoting not only his own work but also his galleries and publications — of which especially 'Camera Work,' which appeared from 1903 to 1917 gained international repute.

Stieglitz recalls taking his photograph *Icy Night, New York* one winter night in 1898: "I had had pneumonia and received strict orders to take care of myself so that I would not have a relapse. One night it snowed very hard. I gazed through a window, wanting to go forth to photograph. I lay in bed trying to figure out how to leave the house without being detected by either my wife or brother. I put on three layers of underwear, two pairs of trousers, two vests, a winter coat, and Tyrolean cape. I tied on my hat, realizing the wind was blowing a gale, and armed with tripod and camera . . . I stole out of the house. I succeeded in getting as far as Fifth Avenue and Sixty-Third Street. The trees on the Park side of the Avenue were coated with ice. The gale blew from the northwest. Pointing the camera south, sheltering it from the wind, I focused. There was a tree — ice-covered,

'Camera Work,' Cover

glistening—and the snow-covered sidewalk. Nothing comparable had been photographed before, under such conditions. My mustache was frozen stiff. My hands were bitter cold in spite of heavy gloves. The frosty air stung my nose, chin, and ears."[11]

Two years before, Stieglitz had succeeded in taking the first nighttime shots in the history of photography. Yet this new image of an icy night pleased him all the more because of the adverse circumstances under which it was produced. After warming up a little as the only nighthawk in the bar of the Savoy Hotel, he battled home against the wind along Sixty-Third Street and returned to bed. When his wife and his brother, the doctor tending to him, saw the photograph two days later, they were horrified to find out about his secret, nocturnal outing.

Four years later, in the winter of 1902, Stieglitz was standing with his camera on the platform of the last car of the train traveling from his parents' home at Lake George, in northern New York state, to Central Station. The train was moving slowly, as it always did at this point when it was late.

All around was suburban sprawl lining the railway tracks as in other cities. The difference was that the New York sprawl was so much bigger—even then—and dirtier and sadder, too. The brightly shining tracks marked the path into town, into the grip of the metropolis, as though churning up a wake of steel and soot, dust and noise. Perhaps everyone who lived there was running away from something—no matter which way they moved—from the city or from the country.

Stieglitz stood on the platform of the car looking through his hand-held camera. He felt the rhythm of the tracks beneath the wheels. He heard the pounding and hissing of the locomotive whose voice was one of impatience. Maybe he sensed

that the journey was like the slow ploughing of a furrow or the fingers of a hand clawing their traces in the earth like the ribbon of tracks embedded in it. Above, echoing the lines of track, were the wires of the Western Union. Tracks and wires, winding and binding simultaneously. Paths of hope, and paths of disappointment. Stieglitz called his photograph *The Hand of Man*, evoking the proverbial hand that plans, builds, and destroys — the hand that holds an unknown destiny.

The photograph provides an unusual vantage point for the period. The center of the picture leads away from the observer, directly into the brightly shining ribbon of the tracks. To the right of center, the tracks are reiterated in a dark cloud of smoke from another locomotive which continues along the upper edge of the picture into the cloudy sky.

Alfred Stieglitz, *An Icy Night*, New York, 1898, from: 'Camera Notes,' October 1901 (vol. 5, no. 2), The Minneapolis Institute of Arts, Minneapolis, MN

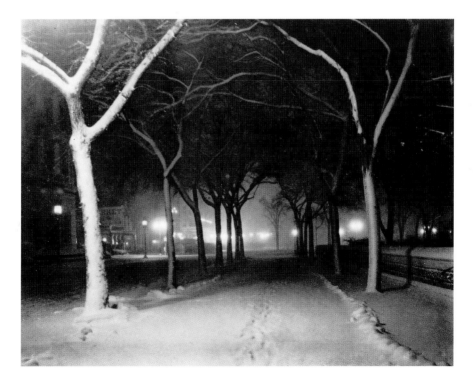

Perhaps the photograph was created out of an ambivalence toward New York, a photograph between pride and doubt. Pride at the size, achievement, and technical progress of the city, undermined by a skepticism in the intellectual progress of America. Later, in 1923, these same doubts prompted Stieglitz to chide the United States in a photograph entitled *Spiritual America*, in which the genitals of a gelding are depicted.

Sometimes, however, his doubts were coupled with enthusiasm at an unforeseen insight, such as he had when the Flatiron Building was built at the junction of Broadway and Fifth Avenue. It was not so much the building itself that impressed Stieglitz as it was the juxtaposition of its tall and slender edifice against the snow-covered trees of Madison Square. The building, according to Stieglitz, "appeared to be moving toward me like the bow of a monster ocean steamer—a picture of new America still in the making."[12] He took a photograph of it, entitled *The Flatiron Building*, in 1903.

Alfred Stieglitz, *The Hand of Man*, Long Island City, New York, 1902, Courtesy Museum of Fine Arts, Boston, MA, Gift of Alfred Stieglitz

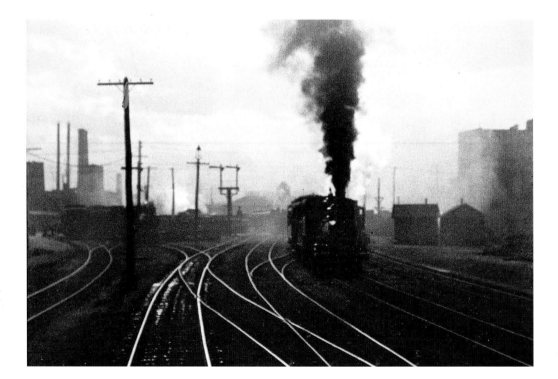

Alfred Stieglitz, *Spiritual
America*, New York, 1923,
Courtesy Museum of Fine
Arts, Boston, MA, Gift of
Georgia O'Keeffe, 1950

Four years later, he was on his way once more to the Old
World, which he still regarded as a kind of homeland. In those
days, it was a long journey that left plenty of time to prepare
one's mind for the change of continents. Thus, upon disem-
barking, one had put the place of departure at such a distance
that new impressions and encounters could be more freely
absorbed. When Stieglitz left the ship at Calais, however, he
was by no means free. He was preoccupied with a scene that he
had encountered on the journey.

Stieglitz had not felt at ease among the first-class passengers;
he disliked the people, their conversations, and their limited
interests. He withdrew to his deckchair, while his wife enjoyed
the casual small talk of the moneyed classes. After a few days, he
could no longer stand it and began to explore the ship as far as
was possible. Eventually, he came to the end of the upper deck,
where he stood alone, and looked down into the steerage space.
On a small deck in the draughty bow of the ship, a group of peo-
ple, mostly men, huddled together. Below them, in the opening
of the cramped steerage, women sat with their children, trying
to catch a few rays of sunshine while seeking shelter from the
wind. They were surrounded by baggage, boxes, and sacks. They

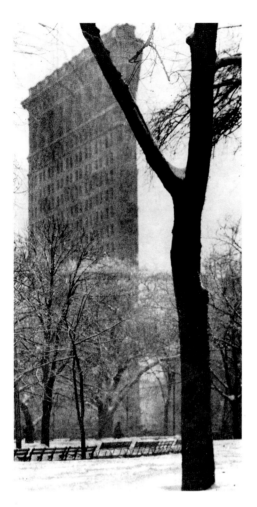

Alfred Stieglitz, *The Flat-iron Building*, New York, 1903, from: 'Camera Work,' No. 4 (October 1903), The Minneapolis Institute of Arts, Minneapolis, MN

were almost motionless and had no air of hope. They even seemed apathetic or indifferent. These were people disappointed by the New World and disillusioned by the cities of America's East coast. They knew that they were going from one life of misery to another, returning to the poverty from which they had once fled with such high hopes. Perhaps some of them were even returning on the same ship, although there are no statistics on how many returned or were sent back.

The only link between them and Stieglitz was a freshly painted gangway bridge. The passengers' lack of freedom was further emphasized by a triangle of metal that surrounded them like the bars of a cage: a massive forecastle mast jutting up on the left, an iron ladder on the right, and the lower spar of the forecastle mast rising above. Framed within was a motley bundle of destinies, wrenched out of the course of time and united for the space of a voyage between continents, only to sink into the poverty of the Old World.

Of this moment Stieglitz wrote: "I stood spellbound for a while. I saw shapes related to one another—a picture of shapes, and underlying it, a new vision that held me: simple people; the feeling of ship, ocean, sky; a sense of release that I was away from the mob called 'rich'.... I raced to the main stairway of the steamer, chased down to my cabin, picked up my Graflex, raced back again, worrying whether or not the man with the straw hat had shifted his position. If he had, the picture I saw would no longer exist. The man with the straw hat had not stirred an inch. The man in the crossed suspenders—he too stood where

he had been, talking. The woman with the child on her lap sat on the floor, motionless. No one had moved. I had only one plate holder with one unexposed plate. Could I catch what I saw and felt? I released the shutter, my heart thumping. Had I captured what I wanted?"[13] When Stieglitz left the ship in Calais, he was still moved by this scene and carried it with him mentally as well as on the negative.

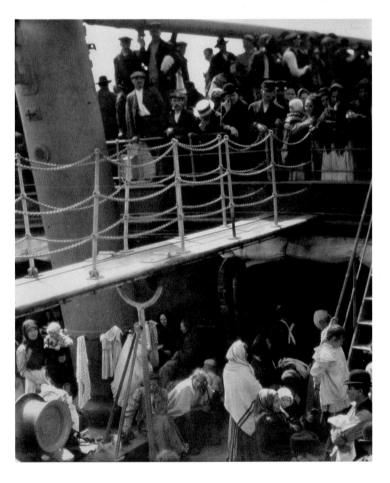

Alfred Stieglitz, *The Steerage*, 1907, The Museum of Modern Art, New York, NY

Georgia O'Keeffe II

When Georgia O'Keeffe first walked through the door of the little gallery on Fifth Avenue, she was not particularly interested in the gallerist, Alfred Stieglitz. What she was interested in was what he had to say. As he talked and made his comments, she looked at images that gave her an entirely new insight into the hidden corners of her own dreams. She found herself glimpsing places she could not fully recognize, places she merely knew harbored the promise of creative independence from the traditional painterly approach nurtured by the academies and schools of art.

On the gallery walls were drawings by the French sculptor, Auguste Rodin. O'Keeffe's teacher had heaped ridicule on these drawings and on the gallerist showing them. That was what had prompted her to visit the gallery in the first place. And there she stood, gazing at Rodin's tender and unbridled hymns to female beauty and sexuality. With pencil, ink, and the subtlest of watercolors, Rodin had put his obsessions on paper. Many years later, O'Keeffe recalled that day in an article published in the 'New York Times Magazine': "There wasn't any place in New York where anything like [the Rodin drawings] were shown at this time or for several years after."[14]

To O'Keeffe, Rodin's images were disturbing, but she liked them for a reason she could not quite put her finger on. They differed so much from all that was familiar to her. Under a veneer of equanimity, she concealed from her friends and fellow students the unease the images triggered within her. Nevertheless, she referred to them in her own drawings a few years later.

O'Keeffe firmly believed that there was an untrodden path in painting that was hers to discover. Yet her search for that path was not easy. She could not share her quest with peers, for she had found no one among her fellow students who was troubled by similar doubts and dreams. Finally, after hearing of the financial difficulties of her parents, who had paid for her studies up to that point, she dropped out of the Art Students League. By then, her technical skills were finely enough honed for her to earn a living as a commercial artist.

Auguste Rodin, *Nude*, c. 1900, in 'Camera Work,' no. 34/35, April–July, 1911

New Ideas

It was almost four years before O'Keeffe resumed painting. By then, her family had left Williamsburg and moved to Charlottesville, a pretty little university town in the heart of Virginia. The University of Virginia, in the family's new hometown, held summer courses for teachers. One of the visiting lecturers, Alan Bement, gave a painting course which O'Keeffe attended along with the art teachers. Bement touched upon precisely those unanswered questions that had troubled O'Keeffe years before in New York. Indeed, not only did he touch upon them–he seemed to promise answers.

Bement was assistant to Arthur W. Dow, who was on the Faculty of Fine Arts at Columbia University Teachers College in New York. Together, they investigated the possible consequences of injecting contemporary Western art with the aesthetic and philosophical principles of East Asian art. (These two spheres were probably never so close as they were during this period, when the influence of Japanese artists, most notably Ogata Korin, helped generate Art Nouveau floral ornament). The rapport between Bement and Dow, born of mutual interest and curiosity, had hitherto led only to an adoption of stylistic elements. In other words, it had been a more or less superficial exchange. A more intellectual meeting of minds was heralded by the theories developed by Arthur Dow — most likely indebted to the foundation laid by Henry P. Bowie at the University of California in 1911 — which he and Bement integrated into the teaching of art. Dow had acquired more than a superficially Oriental stylistic approach: he had adopted a holistic principle from the world of Far Eastern thought that

Georgia O'Keeffe, *Blue No. 1,* 1916, watercolor, 40.3 x 27.9 cm, Brooklyn Museum of Art, Brooklyn, NY, Bequest of Mary T. Cockroft

originated in the Taoist philosophy of Ancient China. It eventually found its way, through painting and religious philosophy, to Japan, where it was perfected by masters such as Sesshu and Shubun in the fifteenth cenotury and has since been handed down and taught through the Kanō schools of Edo and Kyoto. The name of the principle is *in-yō,* and its painterly form is based on *nō-tan.*

The word *in-yō* means shadow (*in*) and light (*yō*) but can be used to refer to male and female, negative and positive, active

and passive, evil and good.[15] The principle maintains that a work of art—and all other things in the world—combines two elements in a balanced relationship. The interesting aspect of the principle is that the equilibrium in the relationship is never perfect. There is always a slight tension between the two contrasting parts that form the whole. If this tension cannot be felt in the work of art, the viewer remains indifferent. This tension—between emptiness and fullness, darker and lighter shades, and in the essence of the subject matter itself—is a result of the state just before the point of either "rupture" or balance, depending on how the situation in the motif would have developed after the point of its appearance in the picture.

The subordinate technical concept of *nō-tan* can be translated in much the same way—dark (*nō*) and light (*tan*)—and involves only shadow and light.[16] What remains is of purely mechanical significance. *Nō-tan* invariably occurs when colors of different values meet in balanced harmony. It is difficult to discuss *nō-tan*—for which O'Keeffe showed little interest on its own—while ignoring *in-yō*, but this is often the case when writing about her work. The principle that Dow and Bement explored was that of *in-yō*, hoping that it might lend new impetus to Western art. O'Keeffe adopted these ideas with eager interest. Gradually, they helped her to achieve the creative independence she so avidly sought. Soon, a tension between light and dark, motion and stasis, weight and levity, the evident and the enigmatic pervaded her paintings, lending them an unadulterated vitality and freshness. Her artistic development was further intensified when she read Wassily Kandinsky's *On the Spiritual in Art*, a theorectical treatise recommended to her by Alan Bement that had been published in 1914. Offering artists the intellectual foundation for a complete break with traditional conventions of painting, the American edition hardly could have appeared at a more opportune time.

Kandinsky suggested a more radical approach to art than had the cubists—after all, the cubists sought to depict the real world. Kandinsky, however, proposed that experience—the "internal" world of the artist—was what determined the forms and colors of a work of art. The external appearances of nature and the material world were no longer obligatory models. According to Kandinsky, the source of creativity and artistic production had shifted to the inner self: "Beauty springs from an internal, psychological necessity. Beauty is what is internally beautiful."[17]

Kandinsky's ideas provided the justification for new exploration within the fine arts. His theory drew its vitality from his own creative approach and personal experiences with the visual world: "A picture is well painted if it has a full inner life."[18]

From 1909 on, Kandinsky numbered his paintings and gave them titles such as *Impression*, *Improvisation*, and *Composition*, thus marking his systematic path towards abstraction. His paintings and theories must have seemed shocking and liberating to his contemporaries.

For O'Keeffe, Kandinsky's paintings were important stepping stones on her path towards personal understanding. Her tormented doubts as to whether there was any point to her endeavors and her fear of laboring in vain had evaporated. She began to concentrate on her own feelings and wishes and pared down the tools of her craft to a minimum in order to work as clearly and directly as possible. She drew with crayons and charcoal, insistently from within. She drew on large sheets of paper that she spread out before her, transposing onto them the traces of her inner feelings. Intuitively, she placed lines and arcs on the off-white of the paper. Never before had she drawn anything like it — nor had she ever seen anything like it. She was almost as surprised by herself as she had been moved by Kandinsky's ideas. She knew that these were very much her own drawings: pictures of her inner self. They were herself.

The new drawings were produced in 1915 in the small cotton town of Columbia, South Carolina, where O'Keeffe was teaching at Columbia College. Two years before, Alan Bement had urged her to impart her knowledge to others. Accordingly, she became his assistant for the summer course in Charlottesville, then worked for two years in Amarillo, Texas, and finally in South Carolina from the fall of 1915.

291

It was around 1915 that O'Keeffe wrote to her friend Anita Pollitzer in New York saying, "I believe I would rather have Stieglitz like something—anything I had done—than anyone else I know of...."[19] The two women often visited his gallery on Fifth Avenue. It was there that they first saw paintings by Matisse, Braque, and Picasso and sculpture by Brancusi. They also saw work by young American artists such as John Marin, Arthur Dove, Marsden Hartley, and Abraham Walkowitz. They listened to Stieglitz talk about these artists, defend them, promote them, and struggle to have them recognized within their own country. They knew that they would find no one in the whole of New York, or indeed America, who so energetically and selflessly promoted the new art of the country.

One day in the late fall of 1915, Anita Pollitzer received a cardboard mailing tube from South Carolina. Upon opening it, she found O'Keeffe's new charcoal drawings along with a note saying that they should not be shown at Teachers College. Pollitzer was moved and excited by the drawings. She was excited because she recognized her friend's obvious progress and moved because she could sense O'Keeffe's immediate presence in the drawings. After looking at the pictures for some time, she rolled them up again and put them back in the tube. Then she gathered her courage, left her apartment, and walked through the cold Manhattan rain to Thirty-First Street and Fifth Avenue.

Stieglitz was alone. He remembered Pollitzer, the young woman who had visited the gallery before, moving silently

from picture to picture. Today, she spoke to him. She asked him if she could show him something. Then she spread out O'Keeffe's drawings, one after another, on the floor in front of him. Stieglitz went slowly from one picture to the next, looking at each one carefully. Occasionally, he moved his hand over a drawing, as though following the course of the lines. Then, after a while, he looked up and remarked that it had been a long time since he had seen pictures of such direct and sensual radiance. Stieglitz was delighted: "I realized I had never seen anything like it before. All my tiredness vanished. I studied the second and the third, exclaiming, 'Finally a woman on paper. A woman gives herself. The miracle has happened.' I looked at a few more of the charcoals, becoming even surer of what I saw."[20] He asked Anita Pollitzer to let him keep the drawings for a while.

At the time, the education of girls and young women was marked by a strongly puritanical element: female sexuality was treated as though it did not exist. To Alfred Stieglitz, the conservative social mores of America were unbearably prudish. What he perceived to be a restrictive climate was undoubtedly an important reason that a modern and timely approach to art was so slowly established.

Where the fulfilment of artistic creativity was concerned, men did not have to contend with quite as many difficulties as women. Yet, there were few young men who could hold their own in an international art world dominated by Europe. Of those who could, most were disciples of Stieglitz. Women artists tended to be trapped by the strictures of convention, and many a major talent was nipped in the bud because of them. No woman could work creatively as an artist when her gender and sexuality were constantly belittled, especially since the free expression of artistic language is closely linked with the expression of sexuality and gender.

There are authors who maintain that Alfred Stieglitz's disparaging remarks about women artists were based on male ignorance and arrogance. To the contrary, Stieglitz was expressing his disappointment at a form of painting that had neither depth of meaning nor true vitality. He was looking for the (American) woman whose artistic work could persuade him to the contrary. One rainy day in the fall of 1915, he had the feeling he had found her: "In the past a few women may have attempted to express themselves in painting. Remember when I say 'themselves' I mean in a universal, impersonal sense. But somehow all the attempts I had seen, until O'Keeffe, were weak because the elemental force and vision...were never overpowering enough to throw off the male shackles."[21]

Alfred Stieglitz was not one for compromise. He demanded that artists identify wholly and completely with their own works. If Stieglitz failed to discern this degree of identity in a work of art, his criticism could be cruel and scathing. Time and again, he spoke of truth as the life source of art:

> I was born in Hoboken.
> I am an American.
> Photography is my passion,
> the search for truth my obsession.[22]

He had already chosen America as his homeland when he wrote these words, and he had come to terms with its cultural and intellectual spirit—his photograph *Spiritual America* had yet to be produced. He also sensed that America needed him, if a truly American form of art was to be developed.

Stieglitz's contribution to that form was his pursuit of a new and highly personal path to art—one that was more or less free from the influence of the European avant-garde. The artists he promoted included the painters Charles Demuth, Arthur Dove, Marsden Hartley, and John Marin, and the young

Alfred Stieglitz,
John Marin, 1921–22,
Courtesy Museum of Fine
Arts, Boston, MA, Gift of
Alfred Stieglitz, 1924

photographer Paul Strand. Moreover, a remarkable young woman also appeared on his roster. Her name was Georgia O'Keeffe.

In 1940, shortly after meeting Alfred Stieglitz, Henry Miller wrote: "People are often irritated with him because he doesn't behave like an art dealer. They say he is shrewd or quixotic or unpredictable—God knows what they all say. They never ask themselves what would have happened to Marin or O'Keeffe or the others if their works had fallen into other hands. To be sure, John Marin might have received more money for his work than Stieglitz was ever able to secure for him. But would John Marin be the man he is today?"[23]

On May 23, 1916, Stieglitz included ten of the charcoal drawings by O'Keeffe that he had been given by Anita Pollitzer in a group exhibition alongside works by Charles Duncan and René Lafferty. Strangely, he did not inform O'Keeffe of the project, perhaps out of fear that she would object, for he knew how this young artist felt about her work. Yet it was exactly what he had been looking for: total correspondence between the artist's feelings and the work of art, sketched worlds in which the unknown has an irresistible appeal. They draw the spectator into swirling circles and into a captivating outline of femininity, tempting thoughts that are as precious as they are unforgettable. For O'Keeffe, the public presentation of these works must have seemed like a breach of trust in which her innermost feelings and thoughts were laid bare. From what Stieglitz had read into her drawings, he had reason to suppose that she would not agree to an exhibition, but in order to avoid lengthy

and possibly futile negotiations, he chose to take a path that seems rather unfair. When O'Keeffe heard about the exhibition by chance, she stormed off to the gallery, where she saw how her drawings had been carefully framed and hung in the largest of the three exhibition rooms. The two other artists— both male—whose work was being shown at the same time, had to make do with the smaller rooms. As Stieglitz recalled:

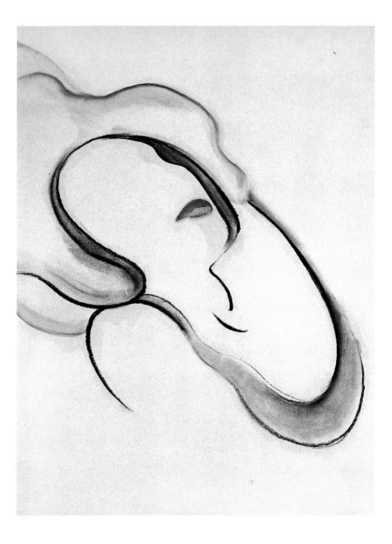

Georgia O'Keeffe, *Abstraction IX*, 1916, charcoal on paper, 61.6 x 47.6 cm, The Metropolitan Museum of Art, New York, NY, Alfred Stieglitz Collection

Then a girl appeared—thin, in a simple black dress with a little white collar. She had a sort of Mona Lisa smile. "Who gave you permission to hang these drawings?" she inquired. "No one," I replied. Still with a smile, she stated very positively, "You will have to take them down." "I think you are mistaken," I answered. "Well, I made the drawings. I am Georgia O'Keeffe." "You have no more right to withhold these pictures," I said, "than to withdraw a child from the world, had you given birth to one." She seemed rather surprised.[24] After that, he invited her to lunch.

O'Keeffe gave her charcoal drawings the title *Specials*, having realized the significance they actually had for herself and others. Some time later, Stieglitz received another cardboard mailing tube. This time it was sent to him directly. He immediately recognized the writing. "In the tube were watercolors—incredible things. I was aghast that anyone could be so careless as to send such wonders in a roll, with six cents postage." When Arthur Dove saw them he said: "Stieglitz, this girl is doing naturally what many of us fellows are trying to do, and failing."[25]

The watercolors Stieglitz received in 1917 had been painted the same year in Texas, where O'Keeffe had been appointed head of the art department at West Texas State Normal College in Canyon, just south of Amarillo. In contrast to her monochrome charcoals, the new watercolors, such as *Red Mesa*, had stronger colors and were executed with a light, free touch that revealed an astonishing correlation between landscape contours and inner relaxation. They were free, wild, and vibrant, suggesting a love of life in the primeval landscape of sandstone, prairie grass, and sunshine. It was this love of life that fascinated Stieglitz. "This was the beginning of what people know as O'Keeffe,"[26] he said.

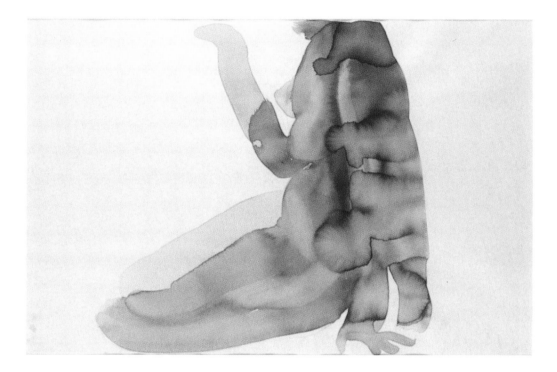

Georgia O'Keeffe, *Nude
Series XII*, 1917, watercolor,
30.5 x 45.4 cm,
Georgia O'Keeffe Museum,
Santa Fe, NM, Gift of The
Burnett Foundation and
The Georgia O'Keeffe
Foundation

Later, she began to produce nudes—a brief interlude in her oeuvre in which the human body rarely plays a role. There were blue nudes and red nudes, all sketched rapidly—as though the Rodin drawings she had seen at Stieglitz's gallery in 1908 had returned to haunt her. Though these sketchy figures speak of her consciousness of her body, she soon left the portrayal of herself and her feminity to another.

From April 3–May 14, 1917, Stieglitz held O'Keeffe's first solo exhibition, which highlighted her charcoal drawings, watercolors, and oil paintings. It was also the last exhibition held at 291, since the old villa had been sold and earmarked for demolition. In June of 1917, the gallery that had meant so much to the germination of America's modern art was demolished.

At the same time, 'Camera Work,' the legendary photography periodical that Stieglitz had launched in January 1903 as a vehicle for art photography, and which had become an internationally acclaimed cultural magazine, folded. In faraway Europe, war was raging, and America had been drawn in. However distant the arena of combat was, young Americans were nevertheless hostage to its outcome. This was hardly a time when people were willing to spend money on things of beauty without a twinge of conscience. In its closing stages, 'Camera Work,' which had a print run of one thousand, counted no more than thirty-seven subscribers. Thus, 1917 was a year of valediction for Stieglitz in more than one sense. It was also to be a year of new beginnings, though he may not have realized it at the time.

O'Keeffe had traveled to New York for the opening of her exhibition. While she was there, Stieglitz took the first in a series of photographs that were to form a portrait of

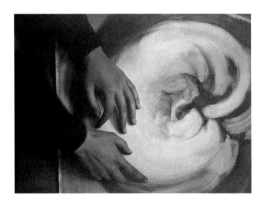

Alfred Stieglitz, *Georgia O'Keeffe, Hands in front of 'Blue I,'* 1917, Private Collection

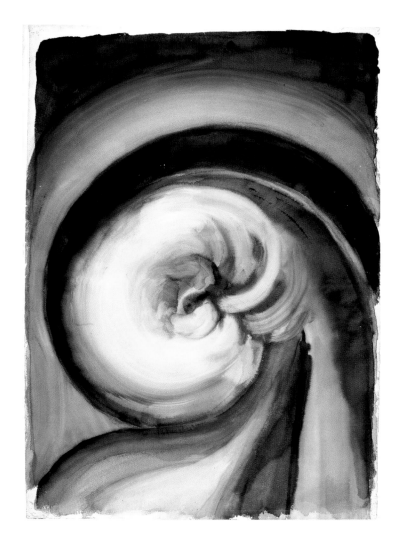

Georgia O'Keeffe, *Blue I*, 1916, watercolor, 78.4 x 56.5 cm, The Tobin Collection, San Antonio, TX

her. The first few photographs, created in the gallery, were of O'Keeffe in front of her own paintings, looking as Stieglitz had described her a year earlier: slender, in a black dress with a white collar. In these photographs, she is reminiscent of the self-portrait of the Italian renaissance artist Sofonisba Anguissola (1535–1625), painted at about the same age. Indeed, these two women had more in common than their dress.

O'Keeffe stayed in New York for three days, then returned to Texas. Stieglitz remained in New York with her watercolors

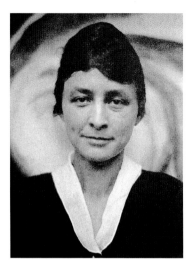

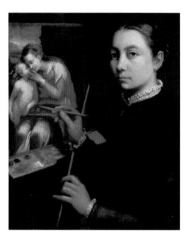

Alfred Stieglitz, *Georgia O'Keeffe with white collar*, 1917, Private Collection

Sofonisba Anguissola, *Self-Portrait*, 1556, oil on canvas, 66 x 57 cm, Collezione Federico Zeri, Mentana

and his negatives. Among them were three plates with images of her hands, which evoked her presence with remarkable intensity. Resting on her painting, *Blue I*, her hands lend the round form of its dynamic blue swirl something moving and corporeal.

When O'Keeffe left, Stieglitz did not feel quite the same as he did before the exhibition opened. He was fifty-three years old, married, and had a seven-year-old daughter — although most of the time, he lived apart from his wife. His niece Elizabeth, who had befriended Georgia, must have noticed a certain emotional unease in her uncle, for in her letters to O'Keeffe, she often asked her to return to New York and even offered her the use of her own studio.

Alfred Stieglitz had a very open, interested, and respectful attitude towards women. During the course of his life, he encountered a number of strong and loving women. For Stieglitz, there was no difference in the way he evaluated men and women. He never accepted or agreed to the subordination of women, and he said as much. However, he felt that women should approach the world with emotion to balance out the sober and rational judgment of men. "They are one together — potentially one always," said Stieglitz.

The Studio in Fifty-Ninth Street

Stieglitz and O'Keeffe kept in touch, and their long-distance correspondence consolidated and strengthened their friendship. The portraits he sent her revealed how much she meant to him. And he had come to mean a great deal to her as well. The age difference meant nothing to her. She liked his angular features and his unruly shock of graying hair. She liked his confident aplomb, his love of art, and the way he gave her his attention, even when they were so far apart. He seemed to be watching over her like the evening star she saw shining over the Texan desert each night—and painted for him (*Evening Star III,* 1917). It was a

Georgia O'Keeffe, *Evening Star III*, 1917, watercolor, 22.5 x 30.2 cm, The Museum of Modern Art, New York, NY, Mr. and Mrs. Donald B. Straus Fund

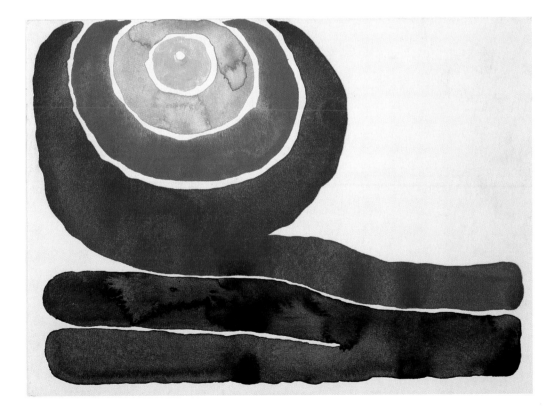

bright lodestar, calmly watching over the land as it sank into darkness when the fiery red of the setting sun was spent.

Later that year, O'Keeffe visited the Rocky Mountains with her sister Claudia (1899–1984). The journey to Denver took them through vast expanses of intensely colored desert country. It was Georgia's first encounter with the landscape of New Mexico, which eventually became her home.

When O'Keeffe returned to New York in 1918, Stieglitz asked her what she wanted most of all to do. Her answer was, "Paint!" At that, he said she could live and work in New York for an entire year at his expense. She gladly accepted the offer and moved into the studio that Stieglitz's niece Elizabeth, the daughter of his brother Leopold, had already offered her.

By the time O'Keeffe decided to move to New York, her artistic personality was already formed, and her relationship with Alfred Stieglitz was one of equals. She stayed on the upper floor of an old brownstone at 114 Fifty-Ninth Street East, not far from Central Park. Stieglitz visited her daily. He would watch her at her work and talk to her about the ideas that concerned them both. And he would take photographs of her. He photographed her with increasing obsession, and their mutual respect, his own photographic mania, and her devotion to his portraiture culminated in a passionate relationship. As O'Keeffe noted:

"The camera always stood near the wall—a box maybe a foot square and four or five inches thick. It stood on its rickety tripod with the black headcloth over it—a bit worn with much use—maybe a bulb hanging down on a small rubber cord. Beside the camera was folded a dirty white umbrella that was a large white circle when opened. It was used to throw light into the shadow. These things were always around nearby so he could grab them

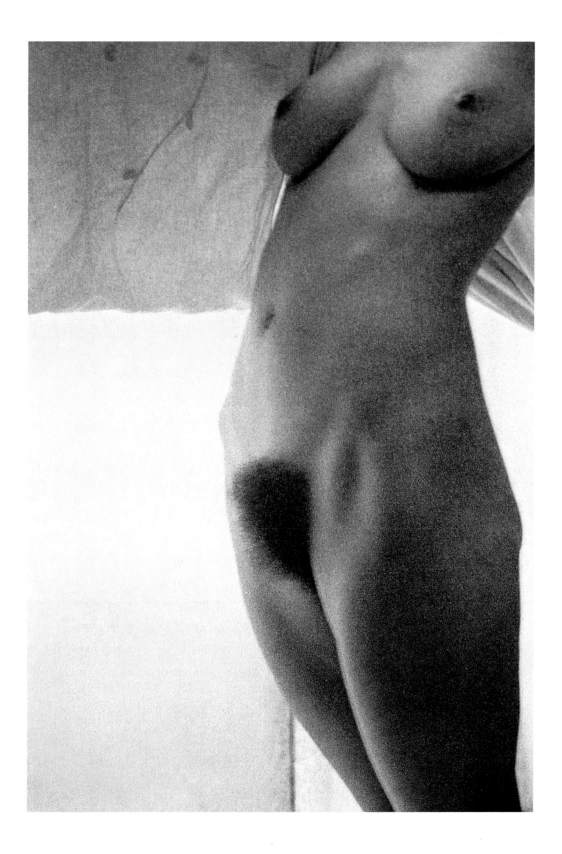

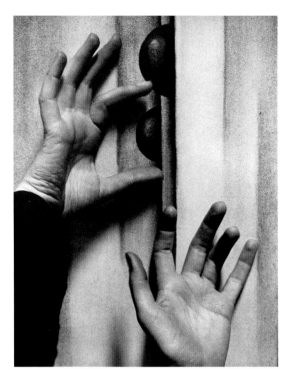

Alfred Stieglitz, *Georgia O'Keeffe, Hands in front of 'Boules,'* 1919, Private Collection

if he saw something that he wanted to photograph. At a certain time of day the light was best for photographing—so at that time we usually tried to be in [the] studio."[27]

With this cumbersome old wooden camera, Stieglitz created portraits that demonstrated how love could be transformed into a work of art. He traced every movement of O'Keeffe's face, hands, and body, following the clear melody of her being. Time and time again, we find traces of the eroticism with which O'Keeffe would imbue her own paintings.

On February 7, 1921, Stieglitz's photographs from this series were presented publicly for the first time at Anderson Galleries on Park Avenue. About a third of the works on display were portraits of O'Keeffe, some forty-five of which were shown. Never before had a photographer so clearly and unequivocally

declared his love for a woman in his work. The critical and public response was positive. Not all of the photographs of O'Keeffe had been taken in the New York studio on Fifty-Ninth Street. That was where the pair spent the colder part of the year. They also escaped the sultry New York summers by staying at the Stieglitz family home, Oaklawn, on Lake George in the Adirondacks, in northern New York state. The lake, mountains, old farm buildings, trees, clouds, and wind became motifs in their works, as both drew their subject matter from their immediate surroundings. No matter where they were, they found inspiration.

The titles of O'Keeffe's paintings frequently refer to her love of music—an inner musicality that perhaps she owed to her father's songs. Between nature and abstraction she sensed sounds and often made them the subject of her art. In 1918 and 1921, for example, she painted *Music, Pink and Blue* as well as

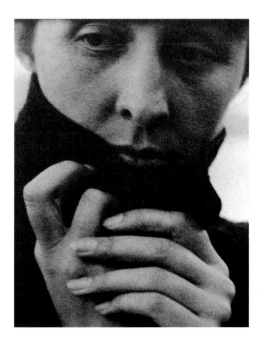

Alfred Stieglitz, *Georgia O'Keeffe, Hands in front of a turned up coat collar*, 1918, Courtesy Museum of Fine Arts, Boston, MA, Gift of the Georgia O'Keeffe Foundation, Sophie M. Friedman Fund and Lucy Dalbiac Fund

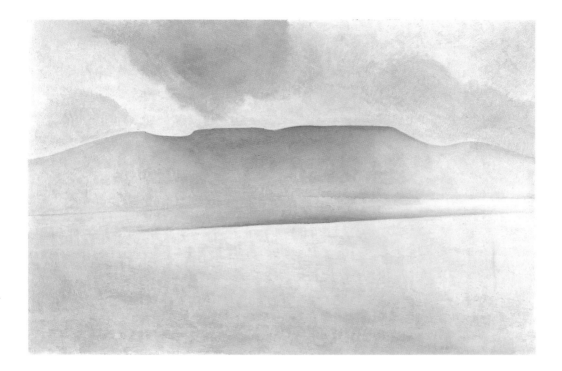

Georgia O'Keeffe, *Shell and Shingle Series VII*, 1926, oil on canvas, 55.3 x 81.3 cm, Museum of Fine Arts, Boston, MA, Alfred Stieglitz Collection, Bequest of Georgia O'Keeffe

Blue and Green Music, both suggesting a dialogue with nature and Stieglitz. It is difficult to imagine a more private or intimate image than that in *Music, Pink and Blue*, which appears to be an outward view seen from within.

The painting may have been intended as a message to Stieglitz, a reiteration of O'Keeffe's desire to have a child by him. Unfortunately, Stieglitz felt that he was too old to bring up another child. He already had a daughter who had suffered much from her parents' separation. What is more, he was financially supporting a number of young artists, including O'Keeffe, and believed a child might hinder his ability to fund them and keep O'Keeffe from painting.

For years, O'Keeffe tried to persuade Stieglitz to have a child with her. It was probably the only wish he was not willing to fulfill and thus is often considered to be the source and subject matter of her painting *Music, Pink and Blue*, among others.

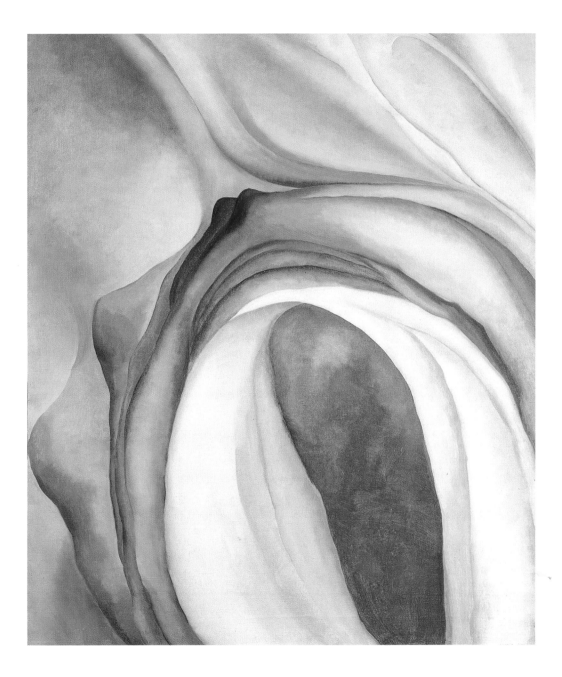

Georgia O'Keeffe, *Music,
Pink and Blue No. 2*,
1918, oil on canvas,
88.9 x 73.7 cm, Whitney
Museum of American
Art, New York, NY, Gift of
Emily Fisher Landau in
honor of Tom Armstrong

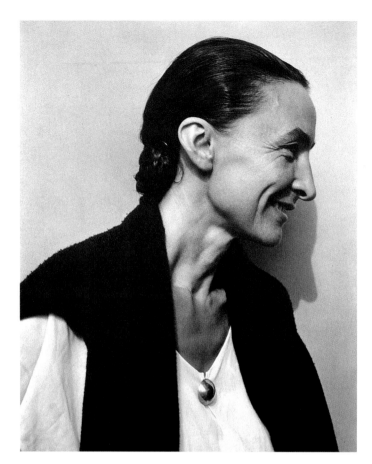

Alfred Stieglitz, *Georgia O'Keeffe, Profile*, 1932, Private Collection

Today, the painting hangs in a New York museum and is generally regarded as enigmatic. In publications, it is reproduced without comment.[28] Yet it is a work that seems to depict the artist's pain—a work with a clearly stated intention.

As time went on, O'Keeffe imbued her paintings with tenderness and sexuality. From 1924 on, she painted very "feminine" flowers, although in the photographs that Stieglitz continued to add to his "portrait" of her, a hardening of the soft lines of her face and body can be detected. Only on the rare occasions when she smiled do we find a temporary transformation—the picture becomes light and beautiful, as in her wonderful profile of 1932.

Alfred Stieglitz, *Self-Portrait*, Philadelphia Museum of Art, Philadelphia, PA: From the Collection of Dorothy Norman

"The world is ringing with sounds. It is a cosmos of beings of a spiritual nature. Dead matter is a living spirit." This is how Kandinsky expressed himself in his essay "On The Question of Form" in the *Blue Rider Almanac* of 1911. Both O'Keeffe and Stieglitz studied Kandinsky's work and theories very closely. However, Stieglitz became aware of the musical element in fine art only through O'Keeffe, whose paintings inspired him—at least from 1923 onward—to follow the inner experience of sounds in his own work. Kandinsky did not intend that music should be imitated by a non-musical art form. In fact, he meant that the artistic expression of a ringing sound could be rendered conscious by the experience. The ringing was the phenomenon that linked the inner and outer experiences that the artist transposed onto the outwood appearance of a work of art.

In 1921 O'Keeffe painted *Blue and Green Music* at Lake George. It depicts an evening scene in which the surface of the lake has been broken by gentle waves formed by the wind.

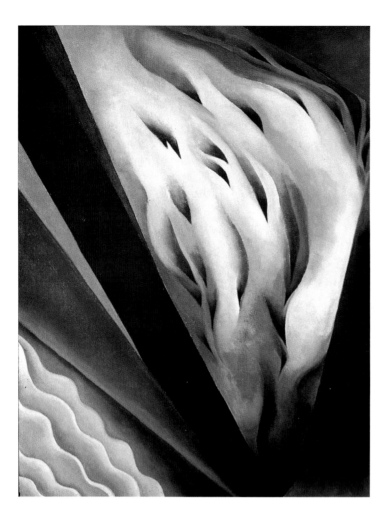

Georgia O'Keeffe, *Blue and Green Music*, 1921, oil on canvas, 58.4 x 48.3 cm, The Art Institute of Chicago, IL, Gift of Georgia O'Keeffe to the Alfred Stieglitz Collection

Alfred Stieglitz, *Equivalent, Mountains and Sky*, Lake George, 1924, Philadelphia Museum of Art, Philadelphia, PA: Gift of Carl Ziegrosser

Green hills and dark, wooded mountains form a barrier between the water and the sky, and clouds, reflecting the pale colors of the evening sun, resemble the flames of a gently burning fire. The deep blue of the night sky is touched by green of the hills. It is a simultaneously calm and exceptionally dynamic painting. In the same way that Stieglitz treated figures in his photograph *The Steerage*, O'Keeffe succeeded in dividing swirling clouds, via straight lines, into three separate sections.

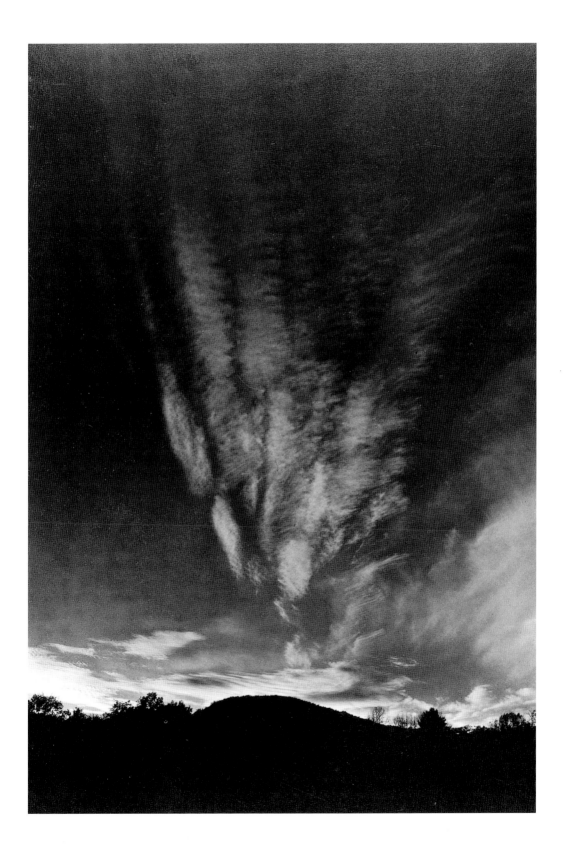

Alfred Stieglitz, *Songs
of the Sky III*, 1923, Cour-
tesy Museum of Fine Arts,
Boston, MA, Gift of Georgia
O'Keeffe

Equivalents

Alfred Stieglitz was profoundly moved by the subject matter of each of his photographs, and he wanted his images to convey that experience to those who saw them. *The Steerage* (1907) is a narrative image that must be studied at length to be fully appreciated. Like any good photograph, it takes effect gradually, continuing to touch viewers over the years.

The Steerage depicts the people on board an ocean steamer and suggests their fates and broken dreams. It also tells us something about Stieglitz, giving us an insight into his thoughts about what he saw, and the respect and sympathy he felt. As in *The Terminal (of the Car Horses)* (1893), *The Hand of Man* (1902), and *The City of Ambition* (1910), Stieglitz imbued the photograph with a depth of meaning that goes far beyond decoration or reproduction.

It is an approach he later intensified, from 1922 onwards, by eliminating the narrative element, the verbosity. He pared down the pictorial content so that, compositionally, his photographs began to approach abstraction. It was a development that took place at a time when O'Keeffe's paintings were emerging out of abstraction and moving towards real and tangible motifs. This was the period during which Stieglitz photographed clouds, a motif he had loved from a very early stage. Early evidence of this interest can be seen hanging on the wall of his friend Paula's room in Berlin. Taken in 1887, and one of his loveliest photographs, it is a tender image bathed in a magical light, a picture of contentment in a time long past—a particularly happy time for Stieglitz. Because he lets us "see" the

woman through his own eyes—she is sitting at the table, writing—we can sense his feelings for her. On the wall of Paula's room are two landscape photographs, both evidently printed from the same negative, that hang next to her portraits. (Writers on Stieglitz have occasionally referred to Paula as a prostitute, but the fact remains that Stieligtz never forgot this friendship, and he continued to support her, financially, for many years after he returned to New York.) The two landscape pictures comprise a single study of clouds that Stieglitz made in 1887 in Bellagio on Lake Como. One year later, the pictures were published, for the first time, in the July 1888 issue of 'Photographische Rundschau,' with precise details regarding the location and circumstances of their production. This study was the start of a fascination that would enthrall him for the rest of his life.

Stieglitz began photographing clouds at a time when it was considered technically unfeasible. To him, of course, this was a challenge he rose to by using orthochromatic negatives and yellow-tinted glass. It was not until several years later that "yellow glass," as the filter was initially known, became a commonly used aid in photography.

The immediate presence of the clouds in his camera's viewfinder—a matte-glass plate under a black cloth—would have its repercussions. Anyone who had seen this breathtaking effect in the viewfinder of a large-format camera would be tempted to focus again and again on the clouds. Thus, photographs of cloud formations can be found throughout Stieglitz's oeuvre.

In 1922 they even took on a life of their own. As Stieglitz focused on the clouds, he searched for something in their formations that would correspond to the world of his own emotions. He had found new fulfilment in his love for a woman,

Alfred Stieglitz, *Sun Rays – Paula –
Berlin*, 1889, Courtesy Museum
of Fine Arts, Boston, MA, Gift of
Georgia O'Keeffe

Alfred Stieglitz, *Equivalent, Set G, No. 1*, 1929,
Courtesy Museum of Fine Arts, Boston, MA,
Gift of Georgia O'Keeffe

Alfred Stieglitz, *Equivalent*, 1926, Courtesy
Museum of Fine Arts, Boston, MA, Gift of
Georgia O'Keeffe

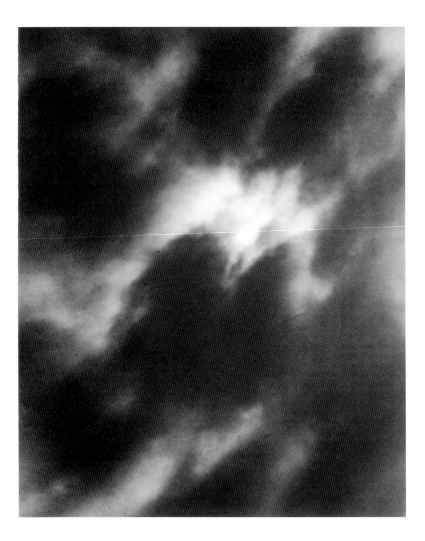

Alfred Stieglitz, *Equivalent*, 1930, Courtesy Museum of Fine Arts, Boston, MA, Gift of Georgia O'Keeffe

had made new friends, had seen the fine arts and music break free of their traditional fetters, and had seen his two "homelands" go to war against each other. In short, he had experienced pain and pleasure, both of which provided a new impetus for his artistic direction.

One year before the outbreak of war, Stieglitz purchased a painting by Wassily Kandinsky. It was the only work by Kandinsky included in the legendary Armory Show, the huge exhibition of contemporary European and American art mounted in the former armory of the 96th Infantry Division on

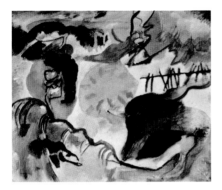

Wassily Kandinsky,
Improvisation No. 27, 1912,
oil on canvas, 120 x 140 cm,
The Metropolitan Museum
of Art, New York, NY

Lexington Avenue. Stieglitz himself had paved the way for this exhibition through his work at 291. In his opinion, the Kandinsky was the most important work in the exhibition, so he bought it, even though he could not really afford it. He simply had to have it near him—and he wanted it to stay in New York. (Today, it is housed in the collection of the Metropolitan Museum.) The painting was Kandinsky's *Improvisation No. 27* of 1912, a painting on the path to abstraction and completed the same same year as his theoretical treatise *On the Spiritual in Art*.

Alfred Stieglitz found in it a confirmation of his approach to photography. Kandinsky's principle of "inner necessity" was, for Stieglitz, a welcome definition of his own working experience. Many times, very much in the spirit of Kandinsky, he had noted that his photographs seemed to take shape enigmatically, as though by themselves, with the composition of the picture emerging almost automatically rather than according to a previously considered formal schema. According to Kandinsky, if the image was generated through the dialogue with the motif, it proved a "spiritually animate subject." Therefore, each photograph brought to life through the synthesis of artist and motif became—and indeed still becomes—part of that truth to which Stieglitz was referring when he so famously said, "Photography is my passion. The search for truth is my obsession."[29]

When Stieglitz focused his camera on the cloud formations in the sky, there were only two people in his circle who understood what he was doing. They were Georgia O'Keeffe and Ananda Kentish Coomaraswamy. For Stieglitz, it marked the beginning of a path towards profoundly internal camera work: it was the path towards his *Equivalents*. In this way, he took

photography to heights it had never reached before. Compositionally, he adopted an approach already practiced years before by O'Keeffe: the reduction of pictorial content to an economical structure of plane, line, and form.

What Stieglitz and O'Keeffe had in common was their endeavor to have their art mirror inner processes. O'Keeffe had begun to delve so far into her motifs that she seemed to lay bare the very souls of them, along with her own. By 1922, Stieglitz, too, had begun to refer to music in connection with his photographs, to which he gave titles such as *Songs of the Sky* or *Songs of the Trees*.

A keen observer of this development in Stieglitz's photographic work was Ananda Coomaraswamy, curator of Asiatic Art at the Museum of Fine Arts in Boston. Dr. Coomaraswamy (1877–1947) was the first scholar of religious studies and art history to make a comparative study of the Asian and European spiritual worlds. Although Indian by birth, he was unencumbered by the patronizing attitude with which western scholars at the time tended to regard other cultures. Incidentally, it was Ananda Coomaraswamy who, in 1934, pointed out the role played by the medieval mysticist Meister Eckehart as a mediator between the eastern and western spiritual worlds.

Coomaraswamy's influence on Stieglitz developed subtly, through his encouragement of a more contemplative photography. According to Coomaraswamy, "The imager must realize a complete self-identification with his vision." Thus confirmed, Stieglitz pushed his work further, until he had achieved in his images an in-depth symbolism and repose. His unerring quest for what he regarded as the truth in his art, his sureness in tracing the essence of things, and his constant alertness, had given his photography an inner stance that related to the traditional art of the Far East.

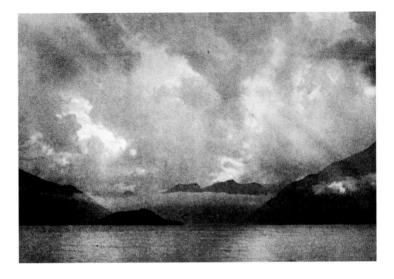

Alfred Stieglitz, *The Approaching Storm*, 1887, collotype, published in: 'Die Photographische Rundschau,' 3rd year, no. 7, 1888

This relationship corresponded to his inner relationship with his own photographs. The seemingly nonfigurative images that were now produced by Stieglitz's camera often possessed enormous beauty. Sumptuous forms characterized this rapid transformation to compositions with ever new pictorial experimentation. All that touched his heart found an equivalent there, as though the sky were the mirror of his soul. Stieglitz described the first photographs in this period as "tiny photographs, direct revelations of a man's world in the sky — documents of eternal relationship. . . ."[30] In speaking of an "eternal relationship," Stieglitz upheld the worldview conveyed to him by Coomaraswamy, according to which all creatures and things in the universe were related to one another. This linked him to Creation in its entirety and confirmed his close relationship to the motifs in his photographs.

Because he was aware of identifying with his subject matter, the Chinese painter Wu Chen (1280–1354) said of himself, "When I begin to paint, I do not know that I am painting. I forget entirely that it is I who is holding the brush in my hand." Soon after his first cloud photographs, which he called *Songs*

of the Sky—later naming them *Equivalents*—Stieglitz himself arrived at a similar conclusion: "I simply function when I take a picture. I do not photograph with preconceived notions about life. I put down what I have to say when I must. That is my role, according to my own way of feeling it. Perhaps it is beyond feeling."[31] In a letter to the president of The Royal Photographic Society of Great Britain, he wrote: "It is the beginning of photography as expression and not merely in the pictorial sense.... My photographs are ever born of an inner need —an Experience of Spirit. I do not make 'pictures.' I have a vision of life and I try to find equivalents for it, sometimes in the form of photographs."[32]

For Stieglitz, the cloud studies confirmed that he had taken the right path. He had led photography towards becoming a medium of directly experienced and profoundly interiorized expressive force. What is more, he had found the truth he sought in conveying his inner feelings about the motif to the visible medium of film. This is, in every respect, what Stieglitz called 'straight photography.'[33]

As soon as the dialogue with the subject matter permitted, the "principle of inner necessity" described by Kandinsky formed the photographic image. To Stieglitz, the outer appearance of the motif was no longer necessarily identical with the statement of photography. His photographs of clouds are not representations of clouds but the musical score of his encounter with his motif—a motif that also tells us about the photographer himself. The idea that photographer and image become "equivalent" in terms of inner truth is the greatest heritage Stieglitz left to creative photography.

In his *Equivalents*, an increasing tendency towards abstraction is evident. The clouds and dark sky were real, but the resulting image is not a photographic portrayal of the sky; it is a subtle

composition of light and shade. Light and shade, dynamic motion and stasis, void and form are reflected in the images that Stieglitz drew from the volatile substance of the sky. The 4 x 5-inch miniatures that he printed as contacts illustrate this path towards the nonfigurative. This is the only one of his visual realms in which O'Keeffe did not accompany him during his lifetime.

Man (looking at a Stieglitz Equivalent): Is this
 a photograph of water?
Stieglitz: What difference does it make of what
 it is a photograph?
Man: But is it a photograph of water?
Stieglitz: I tell you it does not matter.
Man: Well, then is it a picture of the sky?
Stieglitz: It happens to be a picture of the sky.
 But I cannot understand why that is
 of any consequence.

(Recorded by Dorothy Norman, published in 'Aperture,' no. 95, New York, 1984)

Flowers

Georgia O'Keeffe and Alfred Stieglitz married in December 1924, once his divorce had been finalized. By then, the young artist had already come to terms with the fact that she would not have a child by Stieglitz. At the same time, flowers entered her oeuvre. These took on a strangely sensual life of their own and became for her what the *Equivalents* were for Stieglitz. O'Keeffe invested her flower paintings with much tenderness, while at the same time it would seem that her own outward appearance became increasingly hard.

The paintings of huge flowers are O'Keeffe's unique creations, although it is often said that they were inspired by photographer Paul Strand's semi-abstract works after 1916. It is not clear whether Strand was the impetus behind O'Keeffe's choice and interpretation of this particular motif. In Strand's photographs, the motif has no identity and is pure form, whereas in O'Keeffe's paintings, the identity of the motif has a remarkable presence.

The hasty and somewhat facile tendency to compare details from her floral paintings with human genitalia is, perhaps, a little beyond the pale. Admittedly, the flowers have a very strong sensual aura. Yet such an interpretation lacks depth. The remarkably palpable sensuality of these paintings has less to do with O'Keeffe's painstaking rendering of botanical details than with her correspondence between her inner self and the floral motif—as well as the motif's large size. So each painting, as it was created, invariably took on something of the feminine identity of O'Keeffe. Accordingly, the flower paintings brings viewers close to her as a person.

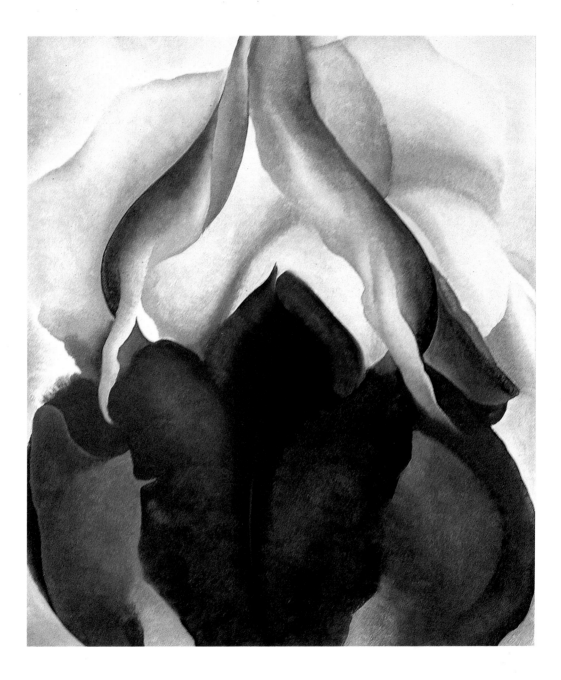

Georgia O'Keeffe, *Black Iris
(The Dark Iris No. III)*,
1926, oil on canvas,
91.4 x 75.9 cm, The Metro-
politan Museum of Art,
New York, NY, Alfred
Stieglitz Collection

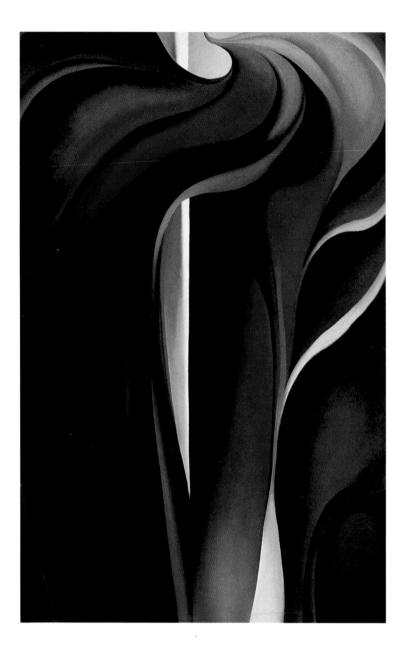

Georgia O'Keeffe,
*Jack-in-Pulpit
Abstraction-No. 5*,
1930, oil on canvas,
121.9 x 76.2 cm, National
Gallery of Art, Washington,
D.C., Alfred Stieglitz
Collection, Bequest of
Georgia O'Keeffe

O'Keeffe's floral motifs are also expressions of her affinity for these "little sisters"—brightly colored plants frequently ignored. She had been familiar with them as a child on her parents' farm. Now she liberated the flowers from their natural dimension and translated them into something much more visible. She freed them from their existence as colored decora-

Georgia O'Keeffe,
Abstraction White Rose,
1927, oil on canvas,
91.4 x 76.2 cm, Georgia
O'Keeffe Museum,
Santa Fe, NM, Gift of
The Burnett Foundation
and The Georgia O'Keeffe
Foundation

tion or botanical phenomena and gave them an undeniable sense of personality.

We shrink before these images. Creation overwhelms us, and we are forced to consider the true relationship between humankind and nature. The huge blossoms demand respect and admiration, and they captivate viewers, forcing those who stand close enough to feel their presence. As O'Keeffe remarked in 1946, "When you take a flower in your hand and really look at it, it is your world for the moment."[34] Her experience of this world is something she perceived as a gift—one

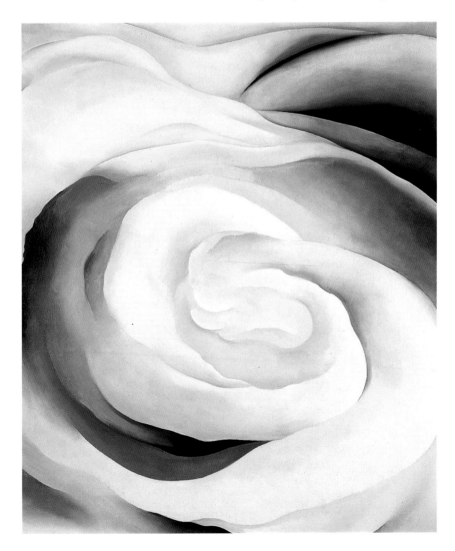

that she passed on with her close-up images. The images, then, are "portraits" in the true sense of the word. They depict characters whose vibrant colors and effusive forms draw us into a dialogue. This is perhaps one reason we never feel alone in their presence.

The flowers are painstakingly composed and often enigmatic —calla lilies, for example, seem aloof—against their invariably neutral backgrounds of leaves or sky, red sand, or colors such as yellow, red, or white. Each respective blossom is precise and detailed and occasionally reminiscent of motifs in her earlier abstract drawings. *Abstraction White Rose* (1927) depicts an earthly rose blossom within a spiraling cloud of mist. Is this an indication that the little rose is identified with Creation? Or is this the fruit of conversations with Ananda Coomaraswamy, who was also a friend of O'Keeffe's? The painting is almost three feet high and not quite as wide. A strange contradiction seems to lie within its simultaneously turbulent and calm image. Surely there is no other work in which O'Keeffe applied the principle of *in-yō*, that she learned from Alan Bement, with such subtle sophistication. *In-yō*—or the tension between movement and calm, flower and cosmos— takes place, above all, in the thoughts of the artist and the observer. *Nō-tan*, on the other hand, describes the harmony of graphic elements and dark and light shades of color. It makes *in-yō* visible. The two are inseparable.

In *Abstraction White Rose*, tension is anchored in the white core of the spiral, out of which come movement and stasis in equal measure. From this same source come the light and dark colors with which the artist rendered her notion of the blossom.

In the almost balanced visual world of *Black Iris III,* painted in 1926, O'Keeffe created what could be interpreted as an extraor-

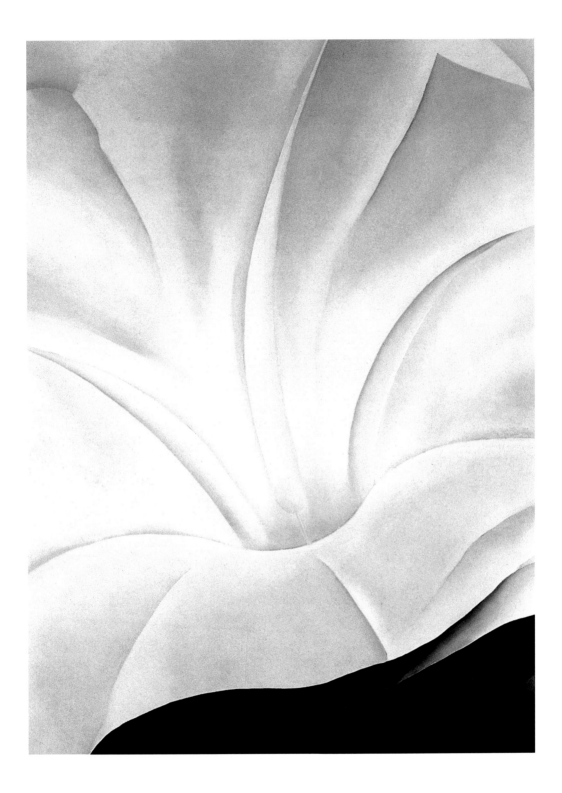

dinary portrait of "the female." Dark and light colors permeate each other only slightly—out of a deep shade of violet arises a bright white and pink. Once again, a floral portrait encompasses an entire world in an image of enormous confidence that relates back to the artist's self.

Georgia O'Keeffe, *Dark Iris*, 1927, oil on canvas, 81.3 x 30.5 cm, Fine Arts Center, Colorado Springs, CO

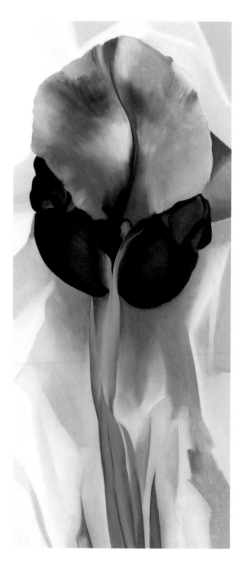

Skyscrapers

In 1928 Georgia O'Keeffe made a painting depicting a small twig, with two tender leaves and a bud, in a pink vase of matte glass. The vase stands on a narrow window ledge. Through the window we can see a landscape that stretches far beyond the East River towards the smoking chimney stacks of Queens. She painted *Pink Dish and Green Leaves* on the upper floor of the Shelton Hotel, where she and Stieglitz had rented accommodations three years earlier. The thirty-story building was the first skyscraper in that part of Manhattan, and O'Keeffe and Stieglitz had watched the steel frame of it rise from the corner of Lexington Avenue and Forty-Ninth Street. They loved being able to look out over the city from such a height.

Alfred Stieglitz had resumed one of his old subjects. Ten years before, he had taken photographs from the windows of 291. Five years before that, he had made his *The City of Ambition* photograph—a photo that could have been produced only by someone who had gained a sense of the seduction and hopes embodied by the highrise skyline as a symbol of the New World. When Stieglitz took the photograph, he was still seeking to forge a deeper link with "his" America by looking for motifs in the city.

In O'Keeffe's paintings of Manhattan's towering skyscrapers, Stieglitz's influence is particularly evident. This is not only because he took his photographs from the same apartment window in the Shelton Building—panning slightly to the right in a sweep that today would be blocked by the United Nations Building—but because O'Keeffe incorporated certain aspects

of photography into her paintings. The most obvious of these
is her handling of light and its reflection in a manner typical of
the effects produced by Stieglitz's camera: bright, often tinted,
spots and dazzling reflections reminiscent of the spots that
appear on a camera's lens when shooting towards the sun.

Another typically photographic effect is her use of perspectival
distortion—normally associated with photographs of tall
buildings and acheived by holding the camera at an angle,
so that the central buildings taper and those on either side
project at a slant into the picture plane.

O'Keeffe incorporated this photographic distortion into her
paintings, producing dynamic effects in her Manhattan works.
To her, as to Stieglitz, this lively city was the epitome of thriv-
ing America—the depression was yet to come. In order to
make this clear, O'Keeffe took obvious pleasure in including
distortions in her paintings that would have spoiled Stieglitz's
photographs. This is particularly evident in two very different
works, both painted in 1926, *The Shelton with Sunspots* and
City Night.

For example, in *The Shelton with Sunspots*, the sun is
reflected in the windows, and the building is barely recogniz-
able. Light spots dominate almost the entire field of vision, and
the edges of neighboring houses jut into the picture at dizzy-
ing angles. Likewise, in *City Night*: a low, full moon is ren-
dered as a tiny spot of light in a window that would otherwise
not be evident. In the background is a brightly illuminated
building that is hidden for the most part. O'Keeffe's perspecti-
val tapering of the dark, high buildings in the foreground
reduces the sense of oppression that might otherwise be
expected in a nighttime urban scene. It is even possible that
the low moon might be a street lamp—for example at the
intersection of Lexington Avenue and Forty-Ninth Street. If

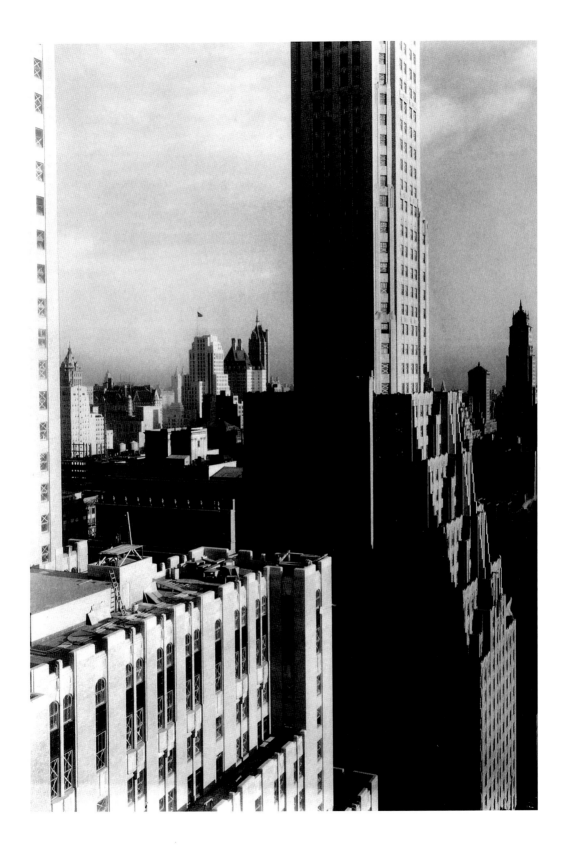

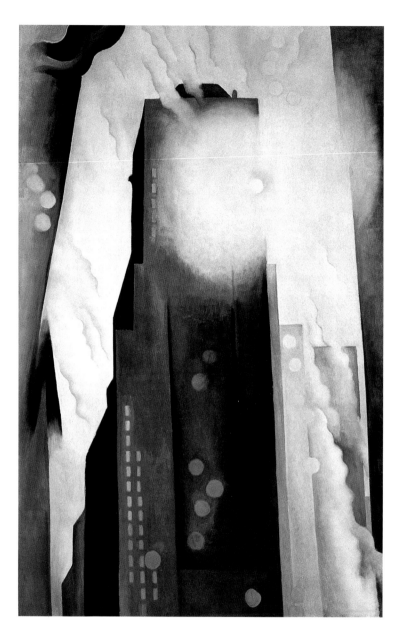

Georgia O'Keeffe, *The Shelton with Sun Spots, N.Y.*, 1926, oil on canvas, 123.2 x 76.8 cm, The Art Institute of Chicago, Chicago, IL, Gift of Leigh B. Block

Georgia O'Keeffe, *City Night*, 1926, oil on canvas, 121.9 x 76.2 cm, The Minneapolis Institute of Arts, Minneapolis, MN, Gift of the Regis Corporation, Mr. and Mrs. W. John Driscoll, The Beim Foundation, the Larsen Fund and by public subscription

that were the case, then the brightly lit building at the juncture might even be the Shelton—the home of O'Keeffe and Stieglitz.

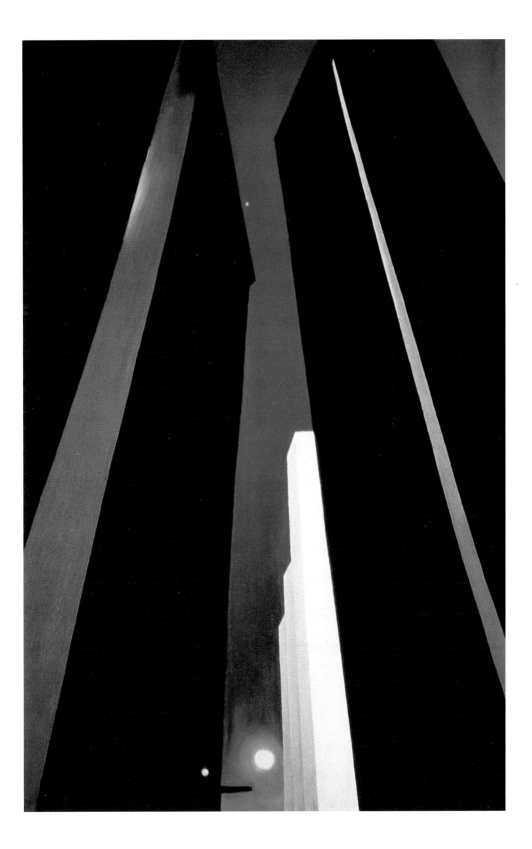

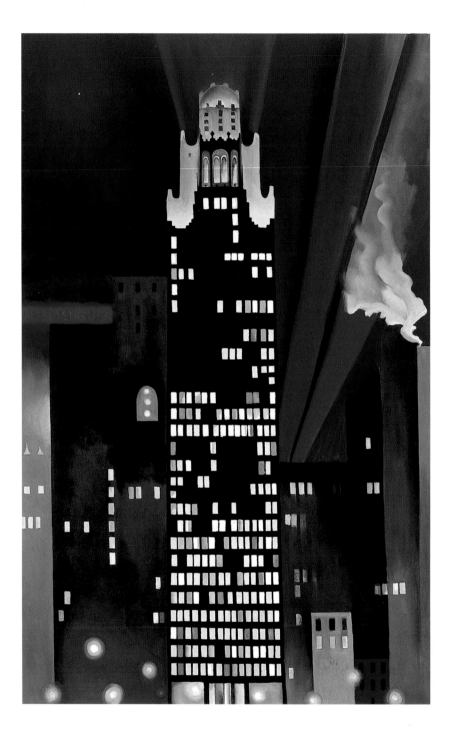

Georgia O'Keeffe, *Radiator Building–Night, New York*, 1927, oil on canvas, 121.9 x 76.2 cm, Fisk University Galleries, Nashville, TN, Alfred Stieglitz Collection, Gift of Georgia O'Keeffe

Alfred Stieglitz, *The City of Ambition*, New York, 1910, Courtesy Museum of Fine Arts, Boston, MA, Gift of Georgia O'Keeffe

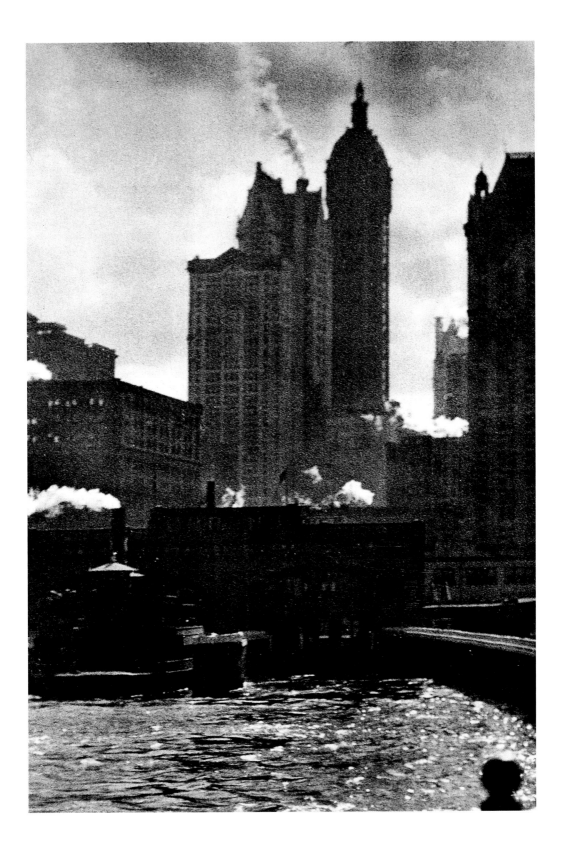

Georgia O'Keeffe,
D. H. Lawrence Pine Tree,
1929, oil on canvas,
78.7 x 99.4 cm, Wadsworth
Athenaeum, Hartford, CT,
The Ella Gallup Sumner and
Mary Catlin Sumner Collec-
tion Fund

Taos

One day, three years after she had painted *City Night*, Georgia O'Keeffe was lying on a bench under a huge pine tree, looking up through its branches at the night sky that covered New Mexico like brightly dotted fabric. The sky was clear, with no urban smog to veil her view. Its reddish trunk grew high like the towering buildings in her New York paintings.

O'Keeffe called the tree "The Lawrence Tree," because D.H. Lawrence, when he visited Kiowa Ranch, had enjoyed sitting under it and writing. In fact, the last chapters of his *Mornings in Mexico* were penned under the old pine in Taos, some thirty miles north of Santa Fe. The ranch belonged to O'Keeffe's friends, Mabel and Tony Luhan. Mabel Dodge Luhan also had lived for a while in the Shelton in New York.

O'Keeffe had come here without Stieglitz, who had chosen to spend some time at Lake George, photographing clouds and being looked after by his family and friends, following a mild heart attack that had left him weak. Stieglitz had come to terms with the fact that he was going to have to spend the summer without O'Keeffe: she had lost her heart to the southwest, which had opened up a whole new dimension in her work. The red sandstone and the bare hills, the bleached bones, the pueblo architecture, and the deep blue skies of New Mexico had taken hold in her paintings.

She continued to spend the cooler months of the year with Stieglitz in New York. Since 1926 he had rented gallery rooms again—the Intimate Gallery (Room 303, 489 Park Avenue,

from 1925 to 1929) and An American Place (Room 1710, 509 Madison Avenue, from 1929 to 1946)—where he presented her latest work every year. Yet, O'Keeffe and Stieglitz were beginning to drift apart. The separation was more physical than emotional. Stieglitz had to spend long periods of time without O'Keeffe, for her new home was far away in the southwest of the United States. He was now sixty-five years old, and a fear of loneliness had crept upon him that even his many friends, including the photographer Ansel Adams, the photographic historians Nancy and Beaumont Newhall, and the young writer Dorothy Norman, could not dispel.

Bones

In 1927 O'Keeffe painted *Red Hill with Sun*, a picture that signaled, in a remarkable way, her future motifs. In it, she rendered the familiar contours of the mountains above Lake George in colors of the landscape she would discover two years later: the red sandstone hills of New Mexico.

Directly above the mountaintop hovers a huge disc—the setting sun—surrounded by a halo in colors ranging from pale blue to deep violet. There is a coolness about the sun disc, as though it had entrusted all its warmth to the diagonal mountain range that draws a line across the picture. The painting is of signal importance because it seems to be an attempt to look at the familiar through new eyes.

Georgia O'Keeffe, *Red Hills with Sun*, 1927, oil on canvas, 68.6 x 81.3 cm, The Phillips Collection, Washington, D.C.

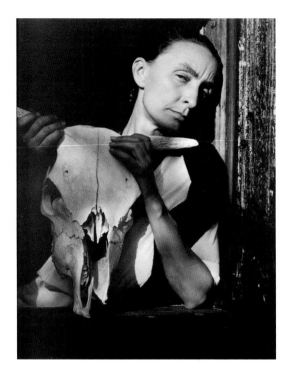

O'Keeffe, like Stieglitz, was always strongly indebted to her immediate surroundings. Wherever she was, she found motifs that inspired her work. However, there came a time when she felt that Lake George had no more to offer, in terms of her work, and she began to look for inspiration elsewhere. One day, the postman delivered a box containing a cow's skull and a heap of other bones to An American Place. Stieglitz was horrified when he unpacked the bleached remains of various creatures—bizarre ghosts of an unfamiliar world, fragments of death and the desert.

Nevertheless, he photographed O'Keeffe at Lake George holding the cow's skull in her hands, as she looks out the window of the wooden shed at Oaklawn. When Stieglitz saw this image emerge in the developing fluid of his darkroom, he might have sensed that O'Keeffe had already chosen to live in a world that was no longer his. The cow's skull seems like a barrier, almost threatening, and O'Keeffe's expression is devoid of intimacy.

At the time, she decorated the same skull with a white artificial flower of the kind that Mexicans often use as funeral decorations. Another such funeral flower appears in her painting *Cow's Skull with Calico Roses* (1932), in which a white skull and white blossom lean against a dirty, white, wooden plank. A dark split in the plank suggests an unknown space. It is a stringently constructed image, with strong black-and-white contrasts, and marks the beginning of the "bone motif" in O'Keeffe's oeuvre.

During the course of her life in the desert region of New Mexico, surrounded by Mexican Catholic rites of death and transience, far from Stieglitz and the hustle and bustle of New York, O'Keefe painted many images whose vibrant colors seem to harbor a dark side. Paintings such as *Pelvis III* (1944) are remarkably similar in composition and essence to her *Music, Pink and Blue* of 1919 and represent the latter part of a life whose triumphs and pain were linked by art.

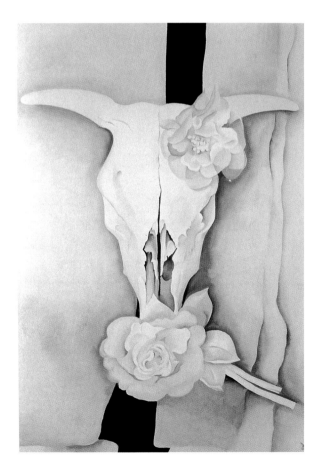

Georgia O'Keeffe, *Cow's Skull with Calico Roses*, 1931, oil on canvas, 91.4 x 61 cm, The Art Institute of Chicago, Chicago, IL, Gift of Georgia O'Keeffe

Metamorphoses

In *Shell and Old Shingle I,* as in other of O'Keefe's paintings, white is the predominant color. It is an innocent white that lends the motif an almost immortal serenity. The painting was created in the same year as *The Shelton with Sunspots* and *City Night* and is an almost abstract still life. Or is it a landscape? Or a view of the lake covered in fog? Or a glimpse into a dream? The image is airy and light, in spite of its formal composition. Subtle tones of grey lend it depth and black provides the firm base that renders the tenderness palpable in the first place—and at the center is something white.

This painting is the result of O'Keeffe's experiments with a shingle, a leaf, and a white shell. She began by placing a shell in front of a wooden shingle that she had positioned vertically and allowing a fleshy leaf to jut from the side. Then she produced painting upon painting, always with the same objects before her. Eventually, she arrived at the fragile and enigmatic image in which the shingle dissolves into the form of a leaf and only a white memory remains of the shell. This poignant rendering of the original theme may be one of O'Keeffe's most beautiful paintings—*Shell and Old Shingle VI* (1926)—in which the shingle has metamorphosed into a leaf form.

The changing appearance of objects is a theme that is addressed in many of her paintings. Two years before, for example, she had painted maple trees at Lake George, concentrating only on the rough and mossy bark of the trunks, so that they seemed to grow from a single root. As though looking through the zoom lens of a camera, she created great depth of

Georgia O'Keeffe, *Shell and Old Shingle VI*, 1926, oil on canvas, 76.2 x 45.7 cm, St. Louis Art Museum, St. Louis, MO, Gift of Charles E. Claggett in memory of Blanche Fischel Claggett

98

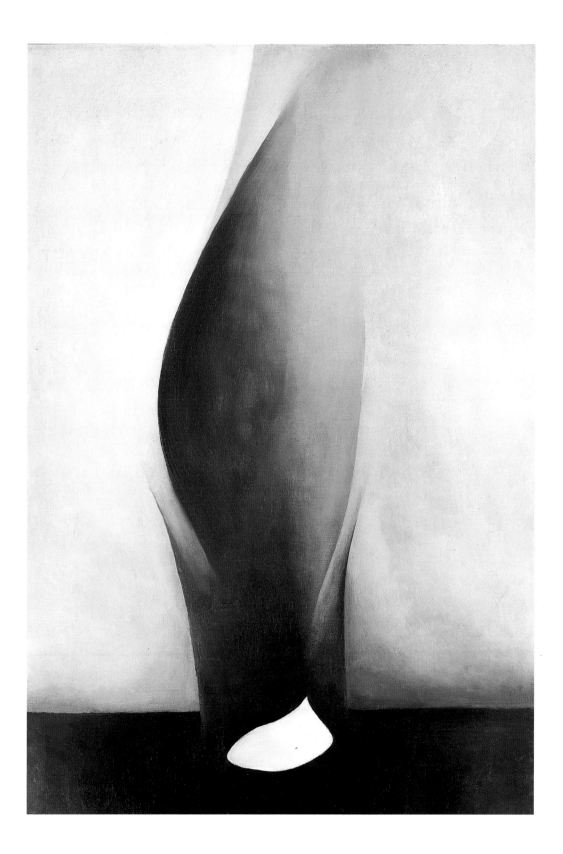

focus: in *Portrait of a Day. Third Day* (1924), a tear in the bark of a hollow trunk takes on the form of a maple leaf. In *Gerald's Tree I* (1937), too, we find a metamorphosis taking place as the dried tree takes on the characteristics of a cactus. Likewise, New Mexico hills seem to take human form as depicted in *Small Purple Hills* (1934).

In the same year in which *Shell and Old Shingle VI* was painted, or possibly shortly afterwards, O'Keeffe produced a remarkable variation on the theme, entitled *Nicotina*, in which the shingle clearly becomes a leaf. Thus, one motif grows out of another and takes on a new existence.

In order to be more mobile in Taos and find out what was beyond the white horizon, O'Keeffe bought herself a car. It was a big, black Model-A Ford. She learned to drive, causing Stieglitz considerable concern, for he hated cars and was constantly worried about O'Keeffe whenever she was not by his side. O'Keeffe even worked in the car, as Ansel Adams recorded in 1937, when he accompanied her to see an eerie tree dried by the sun. In *Gerald's Tree I*, red sandstone mountains and prairie grass form a background for the lifeless tree, which has taken on the traits of a cactus.

The big, black, shiny Ford was an unmistakable symbol of O'Keeffe's independence. Steiglitz had always wanted her to be a confident woman and a respected artist. Yet at the same time, he wanted her to be there for him and dependent upon him. The tension between these two diametrically opposed expectations were occasionally difficult for both to bear. O'Keeffe was indeed confident and respected. But she was not prepared to sacrifice her independence to Stieglitz.

Unwelcome as it may have been, the car provided Steiglitz with one of his most compelling of all his later portraits of O'Keeffe.

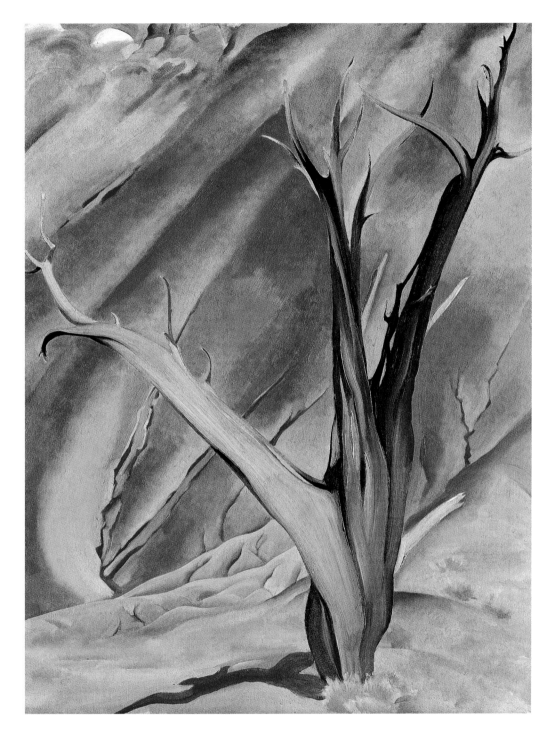

Georgia O'Keeffe, *Gerald's Tree 1*,
1937, oil on canvas, 101.6 x 76.5 cm,
Georgia O'Keeffe Museum, Santa Fe,
NM, Gift of The Burnett Foundation

Hand on wheel (c. 1933–35) is a photograph of classical and fascinating elegance. Georgia O'Keeffe had beautiful, expressive, finely boned hands. For this photograph, she placed her left hand on the spare wheel of her car, resting it nonchalantly on the matte-black metal. The combination of her hand with the elegant, clear-cut forms of technology, became a symbol of female strength and independence.

In 1937 Stieglitz set his camera aside. He was tired and sick and used his remaining energy to cope with the few annual exhibition projects at An American Place, mainly featuring Arthur Dove, John Marin, and Georgia O'Keeffe. Only three exhibitions were dedicated to photography in the last ten years of the gallery, and indeed of Stieglitz's own life: Ansel Adams in 1936, Eliot Porter in 1939, and a final exhibition of his own photographs in 1941. Things had quietened down around Alfred Stieglitz. The man who had once been a driving force behind American modernism was now sinking into oblivion.

Alfred Stieglitz, *Hand on wheel*, 1935 (1933?), The Cleveland Museum of Art, Cleveland, OH

Alfred Stieglitz, *Spring
Showers (The Sweeper)*,
New York, 1902, from:
'Camera Notes,' January
1902 (vol. 5, no. 3), The
Minneapolis Institute of Arts,
Minneapolis, MN

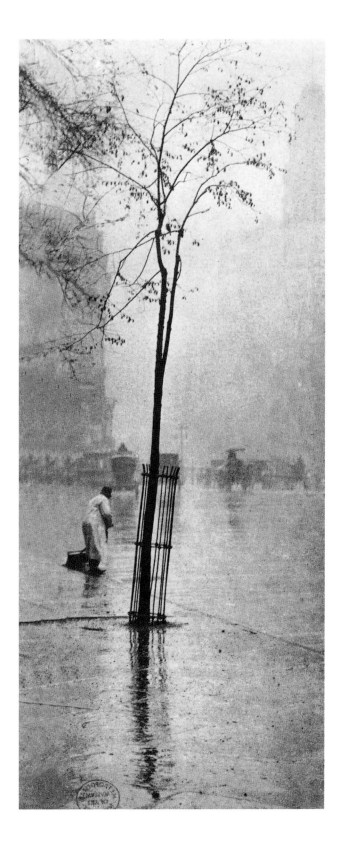

Modernism had found its feet, like a child leaving home, but young American photography had not forgotten him. He had passed on the baton of his quest for truth to many a promising talent. Among them was Dorothy Norman, his last student, Ansel Adams, Wynn Bullock, and Minor White, who administered the heritage of Stieglitz's Equivalents, in its pure form, as a photographer, teacher, and philosopher.

> Sitting on the radiator in the little back room of "An American Place" six months after World War II, we talked about how to take photographs, spoke about the *Equivalents*. Stieglitz said something or other about photography that makes visible the invisible. His talk itself was a kind of equivalent; that is, his words were not related to the sense he was making. If anyone had ever talked like that to me before, I certainly had not heard it. In a few minutes he broke open the lump of poured concrete that had sunk me to the bottom of Leyte Gulf. "Have you ever been in love? . . . Then you can photograph."
>
> (Minor White, *Memorable Fancies*, New York 1946)

Ever since his student days in Berlin, love had been the driving force behind all Stieglitz did: his love of women, especially Georgia O'Keeffe, his love for his friends, his love of photography, and his love of art. He died on July 13, 1946, in the arms of Georgia O'Keeffe. She buried his ashes beneath a pine tree at Oaklawn.

Ghost Ranch

Once she had put her husband's considerable estate in order, Georgia O'Keeffe moved to the southwest for good. In 1940 she had bought a house and some land on Ghost Ranch in the Chama Valley near Abiquiu, between Santa Fe and the

Georgia O'Keeffe, *Patio with Cloud*, 1956, oil on canvas, 91.4 x 76.2 cm, Milwaukee Art Museum, Milwaukee, WI, Gift of Mrs. Edward R. Wehr

Georgia O'Keeffe, *Ladder to the Moon*, 1958, oil on canvas, 101.6 x 76.2 cm, Collection Emily Fisher Landau, New York, NY

Colorado border. The owner of the ranch was Arthur Newton Pack, one of the first American conservationists and founder and editor of the magazine *Nature*. In 1945 O'Keeffe also purchased an old adobe house in Abiquiu, where she planned to spend the winter without the fear of being cut-off if there was heavy snowfall.

The blue sky, the Indian-Spanish architecture, the sparse vegetation, and the fact that her surroundings were limited to only a few colors and forms led to an even more radical simplification of her paintings. In the courtyard of her house, she created large works—in which large swathes of color and form emerged—with which she paved the way for the colorfield paintings of her younger colleagues, Ellsworth Kelly, Barnett Newman, Kenneth Noland, and Mark Rothko. Sweeping planes of color lent her work an endlessness—as though she were striving to go further beyond the frame.

In the paintings from this period, clay, sand, and sky inform her colors, and straight lines, large and uniform planes, and an evident inclusion of geometry, determine her forms. This geometric aspect is a formal element present in the traditional architecture of the region as a whole.

Then there is the ladder. It is the traditional "front stairs" of the Pueblo Indians, who used to enter their homes via the rooftops. O'Keeffe often slept on the roof of her house in summer, under the open sky that had always been such an important element in her paintings. Perhaps, as she lay there, she thought of the old stories that people still tell in those parts, such as the legend of Saynday, the mythical hero of the Kiowa, who brought his people the sun and then returned to the heavens by a ladder. Supposedly, the five stars of his hand still watch over the region that was once the land of the Kiowa. O'Keeffe included these ancient myths in her paintings.

It is night. In the background are the mountains beyond the Chama River that she could see from the roof of her house at Ghost Ranch. Between the earth and the cosmos hovers the *Ladder to the Moon* (1958).

The View from Above

Georgia O'Keeffe, *It was Blue and Green*, 1960, oil on canvas, 76.2 x 101.6 cm, Whitney Museum of American Art, New York, NY, Lawrence H. Bloedel Bequest

Georgia O'Keeffe, *From the Lake, No. 3*, 1924, oil on canvas, 91.4 x 76.2 cm, Philadelphia Museum of Art, Alfred Stieglitz Collection: Bequest of Georgia O'Keeffe, Philadelphia, PA

During in the early fifties, O'Keeffe explored the world. Her curiosity and thirst for knowledge drew her out of her desert isolation, and she traveled throughout Europe, South America, and Asia. At the age of sixty-five, she saw the world from an airplane for the first time—a totally new way of seeing that overwhelmed her. The surface of the earth rolled away below her like a huge, abstract sculpture. Perhaps it reminded her of a painting she had made at Lake George, when she had looked down from above onto a scene that fascinated her. In *On the Lake III* (1924), we find lines under water, stones, moss, sod-

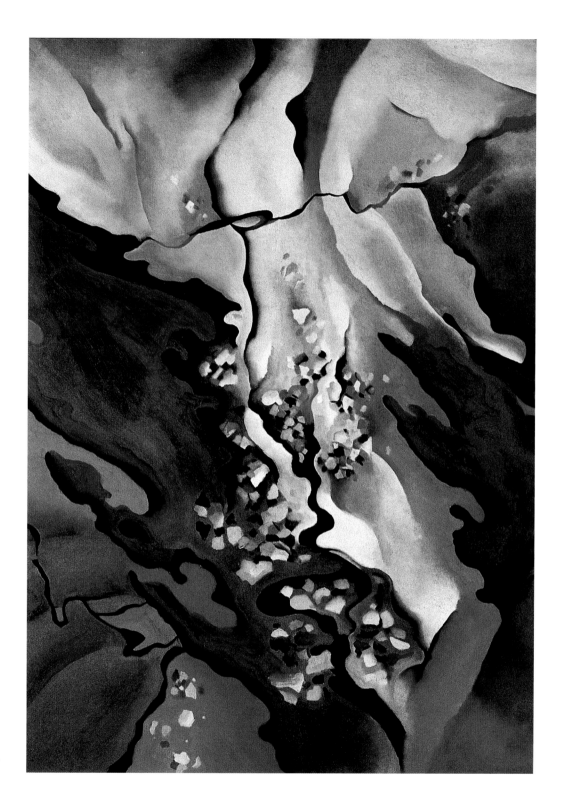

den leaves, and shadows by which the shimmering sunshine seems to create an abstract drawing.

In the fifties, O'Keeffe again made abstractive paintings which, when we look at them, seem to suggest something specific: *It was Red and Pink* (1959) or *It was Blue and Green* (1960). They are abstract, and yet they are drawn from the real world: sand dunes with their comb-like lines, sunny planes and shadows, or details of the earth seen from above.

At the age of seventy-eight, O'Keeffe painted her huge *Sky above Clouds IV*. At seven by two-and-a-half meters, it is the largest of all her paintings. She stretched the canvas in her garage and was working untiringly on it as a way to encounter Stieglitz's *Equivalents*. In the endless expanse of the sky, such as she had experienced when flying, we find an echo of the faith that she and Stieglitz shared in the indivisibility of art and life.

Ansel Adams, reminiscing on times spent with Georgia O'Keeffe and Alfred Stieglitz, remarked at the end of his autobiography: "Stieglitz taught me what was to become my guiding principle: Art is the confirmation of life."

Georgia O'Keeffe, *It was
Red and Pink*, 1959, oil on
canvas, 76.5 x 101.6 cm,
Milwaukee Art Museum,
Milwaukee, WI, Gift of Mrs.
Harry Lynde Bradley

Like an Early Abstraction

In 1971 Georgia O'Keeffe realized, to her horror, that she was losing her sight. The deterioration was so rapid that soon her surroundings and canvases were only a blur. As she lost what was most precious to her, she wondered how she could express herself in art if she was no longer able to see.

One day, a young man came to her door looking for work. "He came just in the moment I needed him desperately," remarked O'Keeffe. Juan Hamilton was heaven-sent. He was a sculptor and ceramist whom O'Keeffe believed possessed all of the qualities of an outstanding artist. His presence and assistance gave her new courage. He "saw" for her the colors that she wanted to use in her work, which allowed her to start painting again, and she was inspired by his presence and genuine affection, which she reciprocated. At the end of her long life, he was the fulfillment of a wish she had given up decades before and had almost forgotten.[35]

In her ninetieth year, working with Hamilton, she painted a series of watercolors that recalled those Stieglitz had shown at her first exhibition at 291. One of them even bore the title *Like an early Abstraction*.

Georgia O'Keeffe died on March 6, 1986, at the age of ninety-eight, in a Santa Fe hospital. In accordance with her wishes, her ashes were scattered by Juan Hamilton on Ghost Ranch, in the landscape that had inspired her paintings.

Alfred Stieglitz, *Charles Demuth*, 1915,
Private Collection

"In the canvases of Georgia O'Keeffe
each color almost regains the fun
it must have felt within itself, on
forming the first rainbow."

Charles Demuth, 1927

Endnotes

1 James Abbott McNeill Whistler (1834–1903) should also be mentioned here in this respect. Looking for the 'American' in him is barely possible. He is one of the rare exceptions. Born in America in 1834, he spent his whole life in Europe. He died in 1903 in Paris. The clarity of his drawing and the structure of his painting hint at the 'fantasy-like' atmosphere in his subject matter. Whistler was a poet who was able to give even the most unlikely motif an air of beauty. The influence that Japanese woodcuts and Persian miniatures had on him lent his art that secretive touch, rendering his oeuvre so 'un-American,' even at a second glance. Whistler's influence on the photography of his time is remarkable: the style of Alvin Langdon Coburn's work during his most crucial phase (1902–12) is attributable to his close study of Whistler's soft, 'blurred' use of lines (*Old Battersea Bridge*); Edward Steichen's much admired self-portrait of 1898 would not have existed had he not seen Whistler's portrait of his mother, *Arrangement in Grey and Black*. Stieglitz's drawings of early New York cityscapes, e.g. *Winter, Fifth Avenue* (1893) or *The Flatiron Building* (1903) clearly demonstrate Whistler's influence.

2 Stieglitz and Lewis Hine (who taught his protégé Paul Strand) never became close friends although they knew each other, were the same age, and each respected the other's work. Stieglitz and the deeply committed documentary photographer Hine were equals pursuing utterly different objectives.

3 Hermann Wilhelm Vogel, *Fotografische Kunstlehre oder: Die künstlerischen Grundsätze der Lichtbildnerei*, Berlin 1891.

4 John H. Vanderpoel, *The Human Figure*, New York 1935

5 Dorothy Norman, *Alfred Stieglitz: An American Seer*, New York 1973, 1960, p. 35

6 In 1888 two photographic terms came into being in the USA which are still used today throughout the world: Eastman and KODAK. That year in Rochester, New York, George Eastman (1854–1932) invented roll film (at first gelatine based; replaced in 1889 by cellulose nitrate). For this purpose Eastman constructed a portable box camera and invented the trade name KODAK for both of these products. KODAK is a made up word, chosen because it is easy to remember, and prononceable in most languages.

7 Doris Bry, *Alfred Stieglitz: The Hand Camera — Its Present Importance*, 1897, reprinted in *Photography in Print*, edited by Vicki Goldberg, NY 1981, p. 215

8 Dorothy Norman, *Alfred Stieglitz: An American Seer*, New York 1973, 1960, p. 35

9 Norman, *op. cit.*, p. 36

10 Sadakichi Hartmann, *Alfred Stieglitz: An Art Critic's Estimate*, New York 1898

11 Dorothy Norman, *Alfred Stieglitz: An American Seer*, New York 1973, 1960, pp. 43–44 Stieglitz seldom gave exact technical details about his images, but

in 'Camera Work' nr. 4, 1903, it is stated that '*Icy Night, New York* was taken in January 1898, at 1 a.m., with a Goertz Lens Series III, full opening, and an exposure of three minutes.' I would like to add that it was a Folmer & Schwing 4 x 5 inch Graflex with a double Goerz anastigmat made in 1893, with a 150 mm focal length, and F-number 6.8.

12 Norman, *op. cit.*, p. 45

13 Norman, *op. cit.*, p. 76

14 New York Times Magazine, December 11, 1949, p. 26

15 *Daigenkai*, Tokyo 1957, p. 214

16 *Op. cit.*

17 Wassily Kandinsky, translated from *Über das Geistige in der Kunst* (On the Spiritual in Art), first published in Munich in 1911

18 Kandinsky, *op. cit.*

19 Richard Whelan, *Alfred Stieglitz: A Biography*, Boston 1995, p. 372

20 *Dorothy Norman, Alfred Stieglitz: An American Seer,* New York 1973, 1960, n. p.

21 Norman, *op. cit.*, n. p.

22 Nancy Newhall, *From Adams to Stieglitz*, New York 1989

23 Henry Miller, *The Airconditioned Nightmare*, first published 1945, here: New York 1970, p. 273

24 Dorothy Norman, *Alfred Stieglitz: An American Seer*, New York 1973, 1960, p. 131

25 Norman, *op. cit.*

26 Norman, *op. cit.*

27 Georgia O'Keeffe, in introduction to exhib. cat. for Stieglitz exhibition, 1978, The Metropolitan Museum of Modern Art, New York, 1978

28 For a more obvious example, see Series 1, No. 8, 1919

29 Richard Whelan, *Alfred Stieglitz: A Biography*, Boston 1995, n. p.

30 *Whelan, op. cit.*, p. 451

31 Alfred Stieglitz, in a letter to Ananda Coomaraswamy dated December 31, 1923; here: Dorothy Norman, *Alfred Stieglitz: An American Seer*, New York 1973, 1960, p. 161

32 Alfred Stieglitz, abstract from a letter to the President of The Royal Photographic Society of Great Britain, April 3, 1925, cited in Sarah Greenough and Juan Hamilton, *Alfred Stieglitz: Photographs and Writings*, Washington, D.C. 1983

33 The use of the contemporary term 'straight photography' stems from Sadakichi Hartmann, an American photographic essayist born in Japan. Cf. A Plea for Straight Photography: in 'American Amateur Photographer,' New York, March 1904. 'Straight' here refers to images created purely through photographic means, i.e. without being touched up with a paintbrush to create a painterly effect, as favored by the pictorialists. Sadakichi Hartmann wrote: "What do I call straight photography? ... Rely on your camera, on your eye, on your good taste and your knowledge of composition, consider every fluctuation of color, light, and shade, study lines and values and space division, patiently wait until the scene or object of your pictured vision reveals itself in its supremest moment of beauty. In short, compose the picture which you intend to take so well that the negative will be absolutely perfect and in need of no or but slight manipulation. I do not interfere with the natural qualities of photographic technique.... I want pictorial photography to be recognized as a fine art.... It can only be accomplished by straight photgraphy."

34 Georgia O'Keeffe, in the New York Post, May 1946

35 Shortly after O'Keeffe's death there were many rumors about the relationship between the artist and Juan Hamilton, for which no concrete evidence could be found. An attempt was even made by John Murrell to write a play about the couple entitled *The Faraway Nearby*.

List of Illustrations

Georgia O'Keeffe

Alfred Stieglitz

Comparative Illustrations

Selected Bibliography

Adams, Ansel, *Ansel Adams: An Autobiography*, 1995
———, *Letters and Images, 1916–1984*, Boston 1988
Benke, Britta, *Georgia O'Keeffe 1887–1986: Flowers in the Desert*, 1996
Bowie, Henry P., *On the Laws of Japanese Painting*, New York 1911
Bry, Doris, *Alfred Stieglitz — Photographer*, Boston 1965
Coomaraswamy, Ananda K., *Why Exhibit Works of Art?*, New York 1941
Greenough, Sarah and Juan Hamilton, *Alfred Stieglitz: Photographs & Writings*,
 Washington, D.C.
Hartmann, Sadakichi, *The Valiant Knights of Daguerre*, Los Angeles 1941
Kandinsky, Wassily, *Über das Geistige in der Kunst* (On the Spiritual in Art),
 first published in Munich in 1911
Lisle, Laurie, *A Biography of Georgia O'Keeffe*, 1997
Lynes, Barbara Buhler, *Georgia O'Keeffe: Catalogue Raisonné*, New Haven 1999
Lyons, Nathan, *Photographers on Photography*, Englewood Cliffs 1966
Miller, Henry, *The Air-Conditioned Nightmare*, 1945
Mulligan, Therese (Ed.), *The Photography of Alfred Stieglitz, Georgia O'Keeffe's
 Enduring Legacy*, Rochester 2000
Naef, Weston (Ed.), *In Focus: Alfred Stieglitz*, Los Angeles 1995
Newhall, Beaumont, *Photography: Essays and Images*, New York 1980
Newhall, Beaumont, *History of Photography*, New York 1964
Newhall, Beaumont, *In Plain Sight*, Salt Lake City 1983
Newhall, Nancy, *From Adams to Stieglitz*, New York 1989
Noel, Francis, *The Saynday Stories and other Kiowa Tales*, New York 1960
Norman, Dorothy, *Alfred Stieglitz: An American Seer*, New York 1995
Norman, Dorothy, *America and Alfred Stieglitz: A Collective Portrait*,
 New York 1934
O'Keeffe, Georgia, *A Portrait by Alfred Stieglitz*, New York 1978
O'Keeffe, Georgia, *One Hundred Flowers*, New York 1987
O'Keeffe, Georgia, *In the West*, New York 1989
O'Keeffe, Georgia, *The New York Years*, New York and Munich 1991
Szarkowsky, John, *Alfred Stieglitz at Lake George*, New York 1995
Weber, Eva, *Alfred Stieglitz*, Avenel, NJ 1994
White, Minor, *Mirrors, Messages, Manifestations*, New York 1969

The Author and Publisher would like to thank those copyright owners
who have kindly given their permission for material from previously
published works to be quoted in this volume. The Publisher would be
pleased to hear from any copyright holder who could not be traced.